COLORS OF CONFINEMENT

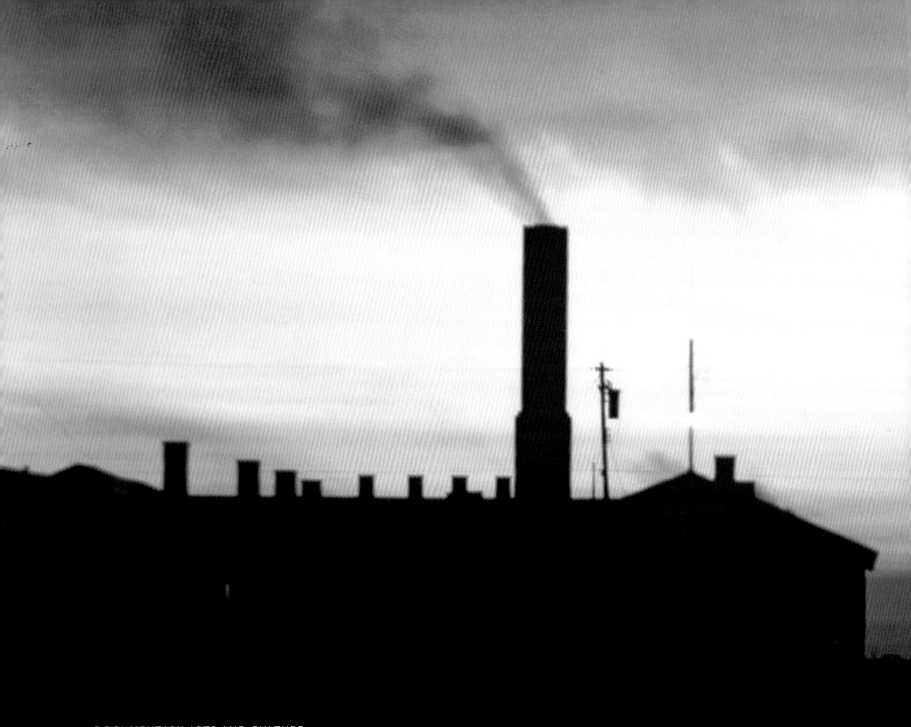

DOCUMENTARY ARTS AND CULTURE

A series edited by Tom Rankin and Iris Tillman Hill

COLORS OF CONFINEMENT

RARE KODACHROME PHOTOGRAPHS OF JAPANESE AMERICAN INCARCERATION IN WORLD WAR II

Edited by Eric L. Muller *With photographs by* Bill Manbo

Published by the

UNIVERSITY OF NORTH CAROLINA PRESS, CHAPEL HILL,

in association with the

CENTER FOR DOCUMENTARY STUDIES AT DUKE UNIVERSITY

"Outside the Frame: Bill Manbo's Color Photographs in Context,"
© 2012 Eric L. Muller.

Unless otherwise noted, all photographs are by Bill Manbo.
Bill Manbo photographs © 2012 Takao Bill Manbo. Bill Manbo's
Kodachrome images are reproduced here with only minor
adjustments to color and contrast.

Kodachrome® is the registered trademark of the Eastman Kodak
Company for its brand of color film.

All rights reserved. Manufactured in China.
Designed and set by Kimberly Bryant in Calluna types.

The paper in this book meets the guidelines for permanence
and durability of the Committee on Production Guidelines
for Book Longevity of the Council on Library Resources. The
University of North Carolina Press has been a member of
the Green Press Initiative since 2003.

Documentary Arts and Culture Drawing on the perspectives
of contemporary artists and writers, the books in this series
offer new and important ways to learn about and engage in
documentary expression, thereby helping to build a historical
and theoretical base for its study and practice.

Center for Documentary Studies at Duke University
documentarystudies.duke.edu

Library of Congress Cataloging-in-Publication Data
Manbo, Bill T., 1908–1992.
Colors of confinement : rare Kodachrome photographs of
Japanese American incarceration in World War II / edited by
Eric L. Muller; with photographs by Bill Manbo.
 p. cm.—(Documentary arts and culture)
Includes bibliographical references and index.
ISBN 978-0-8078-3573-9 (cloth : alk. paper)
1. Japanese Americans—Evacuation and relocation, 1942–1945—
Pictorial works. 2. Heart Mountain Relocation Center (Wyo.)—
Pictorial works. 3. World War, 1939–1945—Concentration
camps—Wyoming—Pictorial works. 4. Manbo, Bill T., 1908–1992.
I. Muller, Eric L. II. Title.
D769.8.A6M327 2012
940.53′1778742—dc23 2011052817

16 15 14 13 12 5 4 3 2 1

to the Manbo & Itaya families

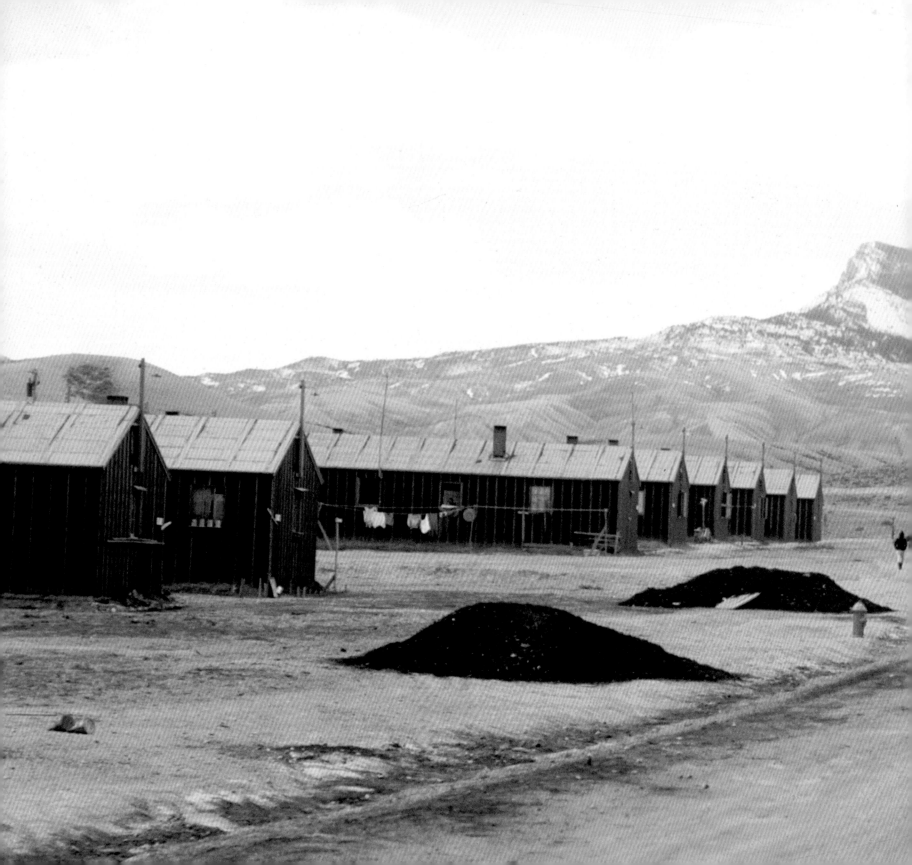

Contents

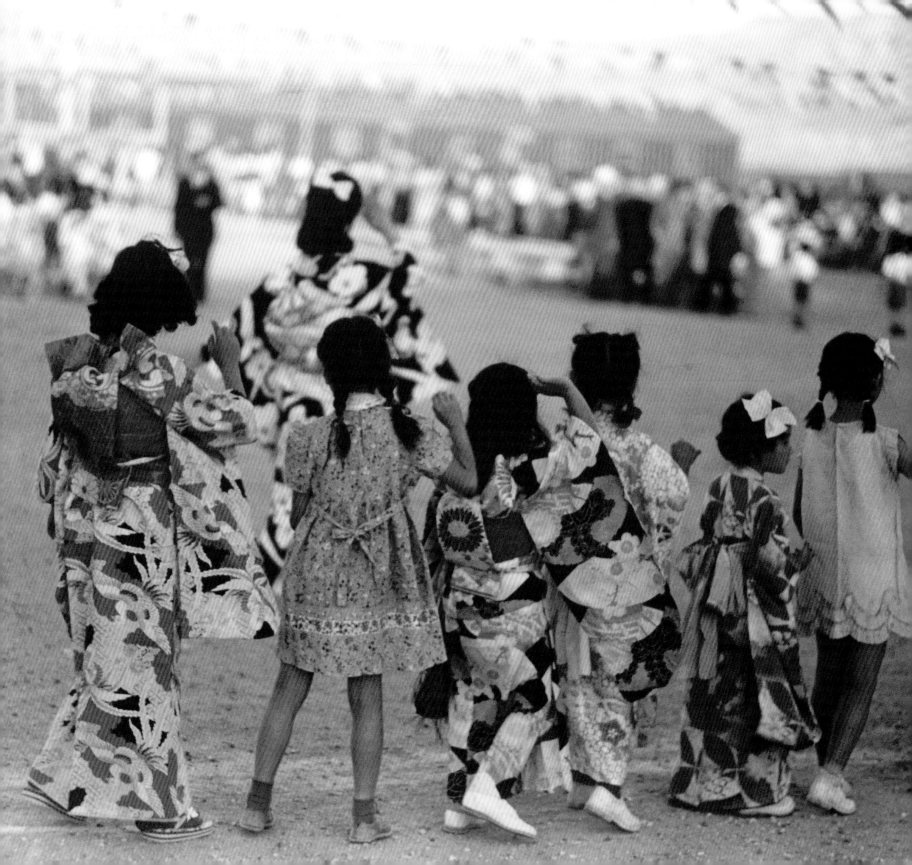

Foreword TOM RANKIN

Colors of Confinement exemplifies the resonant power of documentary expression made at a particularly charged moment in history. The Kodachrome images taken by Bill Manbo have not only lasted through the years but reverberate anew years later in a time far removed from their original creation. While a range of documentarians and journalists made various kinds of records of the realities of Japanese incarceration camps during World War II, Bill Manbo's work is more personal, intimate, and complex. Perhaps beginning with the universal documentary impulse to use the camera to reflect and remember, Manbo made images that bear witness to what he, his family, and others experienced in the internment drama at the Heart Mountain Relocation Center in Wyoming. Now, many years later, his images provide an even wider and more compelling view of this history, one that begins with the personal and extends across the landscapes of time and place.

As Eric Muller eloquently suggests in his opening essay, it's the ambivalence inherent in Manbo's images that keeps us coming back to look and reconsider. And in the essays that follow by Bacon Sakatani, Jasmine Alinder, and Lon Kurashige, we are guided through the photographs and their full depictions from multidimensional vantage points rich in history and ideas of visual representation.

While he directly records the strange and unfortunate circumstances of confinement, he does so through photographs that render much more than the isolation and limitation of camp life. Showing the range of daily life and mobility at Heart Mountain, Manbo's photographs allow us to understand on a fuller level the nature—the true color—of being confined in an imprisonment camp in an unfamiliar and remote place, as people discover myriad ways to maintain individuality, culture, and resilience in a harsh institutional order.

Whether we are initially drawn to these images because of the history of the Japanese American experience or the disquieting brilliance of the visual representation, we find we stay around to look and delve deeper, to try to understand the confluence of narratives represented in Bill Manbo's images. One of the keys to the power of the documentary view is the importance of personal expressions lasting through time. With the introduction of Kodachrome film by Kodak in 1936, amateurs and professionals could make stellar color images with 35mm, hand-held cameras. The longevity of Kodachrome film is an important element in the survival of these rare images. That Manbo decided to make his record on color film is profoundly fortunate and that he chose Kodachrome as his film of choice is the reason we can see them so clearly, so fully.

Bill Manbo's camera and homemade tripod.

ix

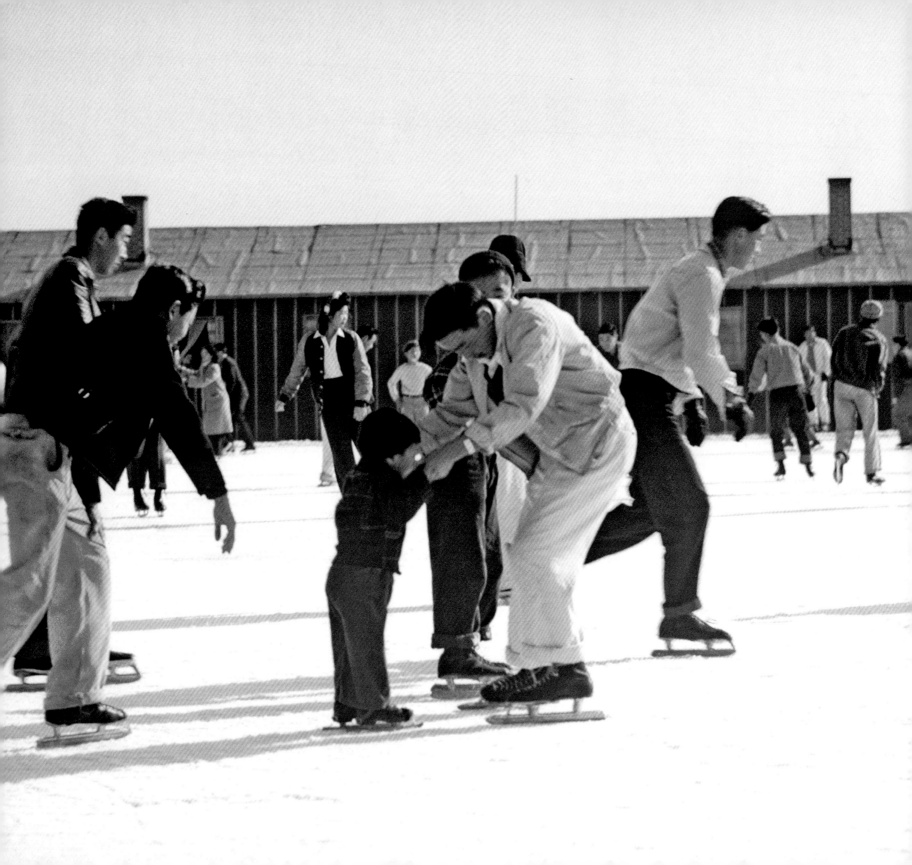

Acknowledgments

I am grateful to Bacon Sakatani for bringing Bill Manbo's color photographs to my attention, and to the photographer's son Bill for trusting me to bring his father's work to a wider audience through the publication of this book. The dedication to the project from Lon Kurashige and Jasmine Alinder has been inspiring from the first moment, and I am indebted to them for their thoughtful and provocative contributions. Roger Daniels and Lane Hirabayashi offered wise advice that helped improve the book tremendously. The staffs of the University of North Carolina Press and the Center for Documentary Studies at Duke University have helped in countless ways to create this beautiful book; Chuck Grench deserves a special thank you for helping me conceptualize the book at an early stage.

My wife, Leslie Branden-Muller, and our daughters, Abby and Nina, offered their eyes, minds, and hearts to me on this project. I love them and am indebted to them in more ways than I can name.

E. L. M.

COLORS OF CONFINEMENT

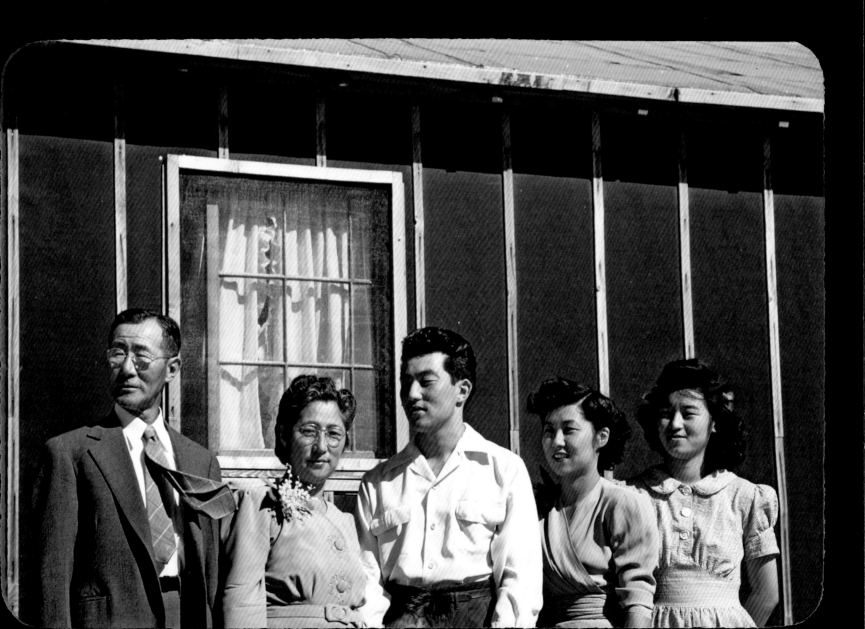

In a family portrait, Junzo Itaya's tie flips in the Wyoming wind. *From left to right*: Junzo Itaya, Riyo Itaya, Sammy Itaya, Mary Manbo, and Eunice Itaya.

Introduction Outside the Frame

Bill Manbo's Color Photographs in Context

ERIC L. MULLER

The photos in this book help us appreciate what the singer-songwriter Paul Simon meant about Kodachrome: its "nice bright colors" really can "make you think all the world's a sunny day." But what if the subject isn't so sunny? That is the problem presented by Bill Manbo's Kodachrome photos of life behind the barbed wire of the Heart Mountain Relocation Center.

The images he made are beautiful. The camp comes alive in the bright white light of midday and the salmon hues of sunset. The subjects are vibrant in their fancy portrait clothing and their scouting uniforms and kimonos. So seductive is the beauty of Bill Manbo's work that we can almost forget we are looking at a site of suffering and injustice. These are photographs of life in a kind of prison camp. However broad their smiles, the people in these pictures were living interrupted lives, or shattered ones. The music of their bright dances and parades masked a hum of dissent and discontent.

The other essays in this book perceptively examine what Bill Manbo's photos reveal about Japanese American culture and community and about the uses of photography in documenting camp life.

This introduction is more concerned with what the photos conceal than what they reveal. A man made these images—a man with a family—and the photos capture seconds in the arc of that man's, and that family's, story. Yet the photographer himself and his family's story stand mostly outside the frame. Only one of the family members pictured in the photos survives: the little boy who was Bill Manbo's favorite subject, his son, also named Bill but called "Billy" within the family. Now in his early seventies, the photographer's son was too young at Heart Mountain to retain any memories of his family's life there, and as was common among Japanese Americans after the war, his family said very little to him about their camp experiences.

However, documents in the family members' "Evacuee Case Files,"[1] discovered in the National Archives, allow us to reconstruct at least some of the narrative. These documents help us understand who Bill Manbo and his family were, what their lives were like before Pearl Harbor, and how they experienced their uprooting and confinement. They help us see how the photographer's and his family's wartime lives reflected larger patterns in

the Japanese American experience of dislocation and broader trends in the documented history of the Heart Mountain Relocation Center. They add more somber shades to Bill Manbo's brilliant photographic studies of the colors of confinement.

Three generations of people of Japanese ancestry were confined at Heart Mountain. The oldest group was the "Issei," a Japanese term for "first generation." These were Japanese who had come to the United States in the late nineteenth and early twentieth centuries. Typically it was the men who came first, seeking economic opportunity, avoidance of mandatory military service, or escape from other social and economic problems roiling Japan as it came through the intense period of modernization called the Meiji Restoration. Women tended to arrive in the United States a bit later, sometimes as "picture brides" in arranged marriages.

Many Issei envisioned an eventual return to Japan, while some intended to make the United States their permanent home. Whatever their plans and intentions, one thing was certain: they could not become citizens. American law forbade this. Only whites and people of "African nativity" or "African descent" could naturalize.[2] The most a Japanese immigrant could expect was status as a resident alien. And even this limited American welcome narrowed in 1924, when nativist forces in Congress secured passage of the Johnson-Reed Immigration Act, which barred all further immigration by most Asians.

Junzo and Riyo Itaya, the father- and mother-in-law of photographer Bill Manbo pictured on page

10, were of this Issei generation. Junzo, the son of a university professor, was born in 1881 in Tokyo and came to the United States in 1904 with a university degree in mechanical drafting. Riyo was born in 1889 in the northern prefecture of Hokkaido and came to the United States in 1912. Junzo was able to speak, read, and write both English and Japanese; Riyo, however, never acquired much English. They were Christians. Junzo worked a variety of jobs after arriving in the United States, including stints as a dairy farm laborer, a telephone company draftsman, a retail salesman, and owner of both a noodle company and a battery manufacturing company. In 1929, he took up vegetable farming in Norwalk, California, southeast of Los Angeles, and continued farming there right up until he and his family were forced from their home in 1942. His specialty crop was rhubarb; at the time he and his family were forced away, they had ten acres of rhubarb plants in cultivation.[3]

Truck farming was a common line of work for Japanese immigrants along the West Coast in the early twentieth century, and it was an industry in which the Issei achieved stunning success. By around 1940, Japanese farmers were supplying between 30 and 40 percent of all truck crops in California, including more than 90 percent of the snap beans, strawberries, and celery, and about half of the artichokes, cauliflower, cucumbers, and tomatoes. This was a remarkable record, especially given that California law made it illegal for an Issei to own land as of 1913 or to rent it as of 1920, and that Japanese farmers never controlled more than 2 percent of California's agricultural acreage.[4]

The generation that followed the Issei was called

the "Nisei," or second, generation. By the simple fact of their birth in the United States, these children obtained something unavailable to their parents: U.S. citizenship. They grew up as something of a bridge between cultures.[5] The extent of their identification with their parents' native land varied according to a number of factors, especially the extent of their own contact with Japan. A minority of the Nisei generation—perhaps one in six or seven[6]—got some schooling in Japan while living temporarily with grandparents or other relatives; these young people were known as the "Kibei" and developed some sense of mastery of Japanese language and culture, particularly if they spent many years abroad. Most of the Nisei, however, never lived in or traveled to Japan, and got their exposure to Japanese language and culture from their parents and Japanese after-school programs.[7] For the most part, the Nisei generation grew up speaking English, embedded in the American popular culture of their day.

The man who took the photographs in this book, Bill T. Manbo[8] (pictured with his camera in this black-and-white photograph and in color on page 41), was of this Nisei generation, as were his wife, Mary, and Mary's brother Sammy and sister Eunice. Bill was born in Riverside, California, in 1908, to Kaichi and Tayo Manbo, an Issei couple originally from Hiroshima. The family moved to Hollywood before Bill entered junior high school. When Bill was in his early teens, his parents took him and his brother to Japan for nearly two years to live with relatives on their farm, but he did not attend school there. The family did not like living in Japan and returned to California; the delay caused

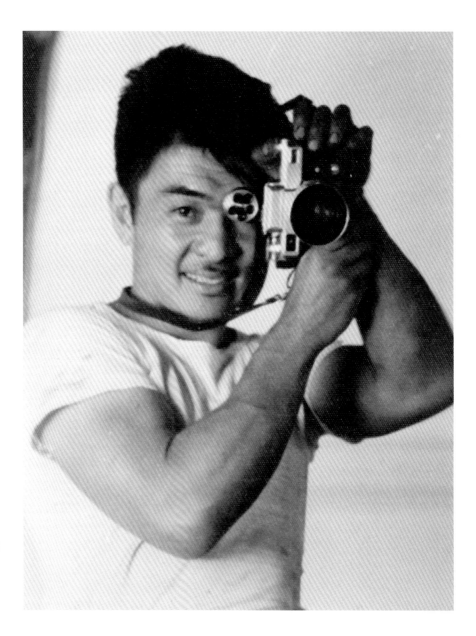

Bill Manbo poses with the camera he used to take the photographs in this book.

Bill to enter high school two years late at the age of seventeen. He graduated from Hollywood High School in the winter of 1929, one of just four Nisei in the overwhelmingly white graduating class of 170 students. His high school yearbook reveals that he was on the gymnastics and archery teams and that his classmates found him "sober."[9]

Bill went from high school to the Frank Wiggins Trade School, where he studied auto mechanics. There he met Junzo and Riyo Itaya's daughter Mary,[10] a dressmaking student. Born in 1912, Mary was the oldest of three children. Her younger brother, Sammy, was born in 1920, and Eunice, the baby of the family, was born in 1925. Mary got her degree from Frank Wiggins in 1933 and then worked as a seamstress and costume designer for a theater company and a private tailor.[11]

Bill and Mary married soon after graduating from Frank Wiggins. Bill opened up a garage on Vine Street in Hollywood, where he made about forty dollars a week painting and repairing cars for a mostly white clientele. Bill dabbled in photography and worked on miniature race cars and model airplanes in his spare time and subscribed to *Model Craftsman*, *Model Airplane News*, and *Popular Photography* magazines. Mary kept up with current events and the fashion world through subscriptions to the *Los Angeles Times*, *Reader's Digest*, *Ladies' Home Journal*, *Life*, *Vogue*, *McCall's*, and *Cosmopolitan*. In 1940, Mary gave birth to a son, whom they named Bill but called Billy.[12] Billy was a member of the third, or "Sansei," generation of Japanese Americans, the generation born to the Nisei. At the time of the Pearl Harbor attack in December of 1941, just before Billy's second birth-

day, only a tiny percentage of the Japanese American community—no more than 8 percent—were Sansei.[13]

That Pearl Harbor attack upended the lives of the Manbo and Itaya families and the rest of the West Coast's ethnically Japanese population. Federal government officials, who for years had been preparing for conflict with Japan and had developed secret lists of Issei community leaders they deemed suspicious, arrested hundreds of Buddhist priests, martial arts instructors, Japanese-language teachers, and leaders of business and community organizations in the days and months following Pearl Harbor.[14] Junzo Itaya, who had been a member of the parent-teacher association of a Japanese-language school in Norwalk and had audited the school's books from 1938 to 1941, was among those arrested. Agents seized him at his home on March 13, 1942, taking him for the night to the Los Angeles County Jail. The next day, they transferred him to the Tuna Canyon Detention Camp in Tujunga, California, and from there to the Justice Department's enemy alien internment camp in Santa Fe, New Mexico. He remained at Santa Fe for more than two months, until the end of May 1942.[15]

These FBI enemy alien arrests rounded up only a relatively small portion of the West Coast's Issei population, and they touched none of the Nisei. For the more than 110,000 people of Japanese ancestry in California, Oregon, and Washington who remained at liberty, life in the weeks and months after Pearl Harbor slowly grew more precarious. Initially there were few calls for mass reprisal against Japanese Americans, and although President Franklin D. Roosevelt stayed quiet on the sub-

ject, his attorney general, Francis Biddle, publicly urged Americans to respect the rights of people of Japanese (and German and Italian) ancestry. As the months wore on, though, the Japanese military smashed its way from island to island across the Western Pacific and Southeast Asia, stoking Americans' anxieties about the safety of Hawaii and even of the West Coast of the continental United States. Rumors of Japanese assault by air, land, and sea circulated. Seeing an opportunity, the nativist groups and agricultural interests that had long sought to kick out the Japanese for racial and economic reasons ramped up their calls for mass removal. A fear-mongering press—not just the thoughtless partisans but even a thoughtful moderate like Walter Lippmann—joined these frightened and cynical voices. And to a man, the congressional delegations of the West Coast states amplified them.

In this pressured atmosphere, military officials developed a plan that included the removal of every person of Japanese ancestry from the West Coast. Even though President Roosevelt's Justice Department argued that the plan was illegal and unnecessary, the military had the upper hand in the debate, and on February 19, 1942, Roosevelt signed Executive Order 9066. This order gave the military blanket authority to designate zones—soon to include the entire coastal strip—from which it could exclude "any or all persons." The government deployed its exclusion authority selectively: while the Justice Department targeted certain German and Italian aliens (but not U.S. citizens of German or Italian ancestry) for arrest and detention, the military ordered the wholesale exclusion of every single person of Japanese ancestry, alien and citizen alike.

From late March through June 1942, neighborhood after neighborhood was emptied of its ethnically Japanese residents. Families typically had little more than a week or two's notice that their time was up, and they were permitted to take with them only what they could carry. These conditions forced them either to make panicked arrangements for their belongings and pets or to abandon them. Neighbors snapped up the real and personal property of the departing families at fire sale prices.

Departure day for the Manbo and Itaya families was April 28, 1942. In the turmoil, Bill and Mary Manbo had to tend not only to their own affairs but also to little Billy, who at that point was a toddler of two. Bill Manbo was forced to leave behind, among many other things,[16] the tools of his trade—his mechanic's tools. Mary's mother, Riyo Itaya, had to face the upheaval of departure without her husband, Junzo, who was still jailed as an enemy alien in New Mexico. Her only supports were her high-school-age daughter, Eunice, and her twenty-one-year-old son, Sammy, who abandoned his studies at Berkeley, where he was an ROTC student, to come home and help prepare for exclusion.

One key item for the Itayas was their ten acres of rhubarb on the Norwalk farmland they rented. The crop was undoubtedly not in top shape because Junzo, its caretaker, had been gone for six weeks, but the roots of the perennial plant were valuable items nonetheless. Sammy dealt with this issue on April 27—just a day before he and his family had to leave—by signing a contract for the care, harvesting, and sale of the crop for the duration of the war. The contract was a three-way arrangement among him, the new tenant replacing the Itayas

as caretakers of the rhubarb, and Paul Wilson, the man the Itayas believed (mistakenly, as it turned out) to be the owner of the land. The contract stipulated that Sammy Itaya was the owner of the rhubarb and that the rhubarb was to be maintained in the ground and returned to him at war's end after Sammy paid Wilson $154 in back rent. During the war, the tenant was to raise the rhubarb and Wilson was to market it. The three were to split equally the profits from the sale of the rhubarb. The contract gave Sammy the right to demand an accounting at any time.[17]

Like the rest of the ethnically Japanese population of the West Coast, on their assigned day the Manbos and the Itayas reported for "evacuation" to barbed-wire enclosures that the government euphemistically called "assembly centers." In reality, the centers were heavily guarded prison camps. Fifteen of them were sprinkled up and down the coast, mostly at fairgrounds and racetracks near major cities.

The Manbo and Itaya families entered the Santa Anita Assembly Center, a prison camp installed at a racetrack in Arcadia, California, about fifteen miles northeast of downtown Los Angeles, on April 28, 1942. (Junzo Itaya did not join them until a month later, after an enemy alien hearing board decided that he was "not potentially dangerous to the security of the United States" and released him on parole from the Santa Fe internment camp.) Life at Santa Anita was considerably harsher than what is pictured in Bill Manbo's photographs of Heart Mountain. More than 18,000 people were corralled at the racetrack. Some 8,500 of them, including the Manbo and Itaya families, resided in hastily

whitewashed stables that stank of the horses that had recently occupied them. Army sentries with weapons guarded the camp's perimeter on foot and from a number of guard towers equipped with searchlights. Families were crammed into tiny spaces. People showered communally where the horses had been washed. People slept on mattresses of straw. Privacy was nonexistent; toilets in the men's latrines had no partitions, while the women's had partitions but no doors. Daily life consisted of lots of standing in long lines and idleness. Some of the Nisei worked for twelve dollars per month at a camouflage netting facility that the government set up, but the Issei were not trusted to do this work.[18]

Unsurprisingly, Santa Anita was not a happy place. In the heat of early August 1942, several thousand Issei and Nisei erupted in rioting when security officers swept through the ramshackle barracks and horse stalls searching for "contraband" items such as small knives, utensils from the mess halls, whiskey, and towels from the latrines. It took hundreds of soldiers to bring the rioters under control.[19]

By mid-August, the government began shipping people out of Santa Anita and the other temporary camps to the ten permanent "relocation centers" set up in desolate parts of the Mountain West and in the swampland of southeastern Arkansas. Heart Mountain was one of the ten camps. Built on federal land managed by the Bureau of Reclamation and operated by a new civilian agency called the War Relocation Authority (WRA), the camp sat between the towns of Cody and Powell in northwest Wyoming, sixty miles to the east of Yellowstone National Park and about forty-five miles south of the Montana border.[20] Residents of the adjacent

communities had little experience with people of Asian ancestry and were understandably apprehensive about the arrival of thousands of people the federal government deemed too dangerous to remain along the West Coast. "Ten Thousand Is a Lot of Japs" screamed the headline of Cody's newspaper as what would become the state's third-largest population center sprang up in the space of just sixty days. That headline surely captured the feelings of many in the region.

The Manbo and Itaya families arrived at Heart Mountain by train on September 4, 1942, about three weeks after the camp opened. The population at that point was approaching 5,000; it would exceed 10,000 by the month of October. The photograph on page 8 gives some sense of the view that greeted them as they came up a small hill from the train depot and encountered a sea of tarpaper barracks on a barren plain beneath the striking lone peak of Heart Mountain. The barracks' "apartments" offered little more than army cots with thin mattresses and blankets, a coal-burning stove, and a bare lightbulb dangling from the ceiling. Bill and Mary Manbo occupied a sixteen- by twenty-foot unit with their two-year-old son; Junzo, Riyo, Sammy, and Eunice Itaya shared a twenty-by-twenty-foot room just two doors down in the same barrack building. They did not need to leave the building to converse with each other; the thin walls between the rooms did not stretch to the ceilings, so noises traveled the full length of the barrack. All basic services—food, laundry, and latrines—were communal. The mess halls, which were hard to stock with enough food for the more than 10,000 mouths to be fed, did not manage to provide reli-able service to every inmate until the middle of 1943. Barbed-wire fences and guard towers surrounded the camp. Through the fall and early winter of 1942, makeshift schools and the camp hospital had only the most basic equipment, and that in short supply. A camp canteen sold certain staples, but most of the inmates acquired much of what they needed to clothe themselves and furnish their living quarters by mail-order, if they could afford it.

It was on the foundation of these experiences of dislocation, deprivation, isolation, turmoil, and stigma that Japanese Americans built the lives pictured in Bill Manbo's Heart Mountain photos. To the extent that the photos show even a semblance of normalcy, that semblance was hard-won.

Many of Bill Manbo's images of life at Heart Mountain capture scenes of beauty, action, and pleasure. He shot the splash of a diver at the swimming hole, the smiles of ice skaters, the concentration of little boys shooting marbles, the graceful movements of colorfully clad dancers at a summer Bon Odori celebration, the bustle of a scout parade, and the clash of sumo wrestlers. Skillfully using a homemade tripod, Manbo captured the subtleties of color in the camp and the sky above it in the challenging photographic conditions of dusk and dawn. In the light of day, he snapped a rainbow that seemed to end at the roof of a latrine, tumultuous efforts to fight a barrack fire, teenagers playing a game of pick-up baseball, and inmates lined up for an afternoon showing of the movie *How Green Was My Valley* at one of the camp's two theaters, both converted from barracks.

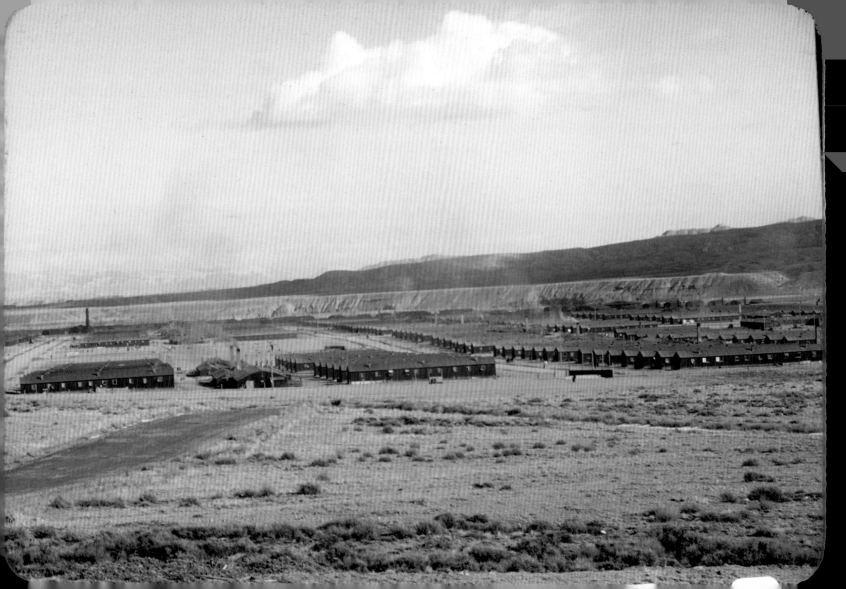

We have to remember, however, that these photos are the work of an amateur family photographer, not a professional documentarian. Bill Manbo used his camera the way most people use them: to capture memories of the exceptional, the exciting, and the beautiful. He did not, for the most part, use his camera to document the monotony and the social control that marked everyday existence at Heart Mountain.

I say "for the most part" because certain photos do seem to reveal Manbo's awareness of confinement and its effects. He had any number of places in and around the camp to shoot a portrait of his young son against an attractive backdrop, yet he decided to capture the boy grasping barbed wire (page 70). In a photo of camp like the one on page 45, the looming guard tower at the center surely was not incidental to Manbo's composition. And the typical portrait of grandparents with their grandson does not feature a grandfather staring absently off into the distance like the photograph on page 10 of Junzo and Riyo Itaya with their grandson Billy. Even in the world of beauty and amusement that Bill Manbo used his camera to memorialize, a sense of his displeasure with incarceration lurks beneath the surface.

Outside that photographic world, in the everyday lives of the inmates at Heart Mountain, monotony and social control were regular features. Many of the prisoners chose to fill their time (and to a modest degree their bank accounts, devastated by their forced exclusion from the West Coast) with work. Heart Mountain was, in effect, a small city, and it needed all of the goods and services required to support a community of more than 10,000 people—agricultural production, food distribution and service, medical care, fire and police services, education, transportation, provision of fuel for heating, building construction and maintenance, a newspaper, and on and on. Between September 1942 and November 1945, Junzo Itaya did carpentry, mechanical drafting, administrative work as a residential block coordinator, and labor on the completion of an irrigation canal for the Bureau of Reclamation. He earned sixteen dollars per month, the WRA rate for semiskilled labor, for all of this work except for the one month on the canal, for which he earned nineteen dollars, the skilled rate. Riyo Itaya worked two stints in her residential block's mess hall, one from July to November 1943 and a second in the fall of 1944 that was cut short by illness after just a few weeks.

Mary Manbo took care of little Billy and did no paid work, but Bill Manbo got a job as a mechanic in the camp's motor pool in late October 1942 and held the job, mostly at a pay rate of nineteen dollars per month, until he left camp to look for work in Cleveland in November 1944. The motor pool job gave Bill a ringside seat to one of the most serious conflicts to roil Heart Mountain during its first year of operation. Late in April 1943, an internee trying to set up the camp's farming operations asked a white administrator of the motor pool for help with a truck, and when that help was not forthcoming, a vicious fistfight broke out between the internee and the administrator. This fight brought to the surface a host of grievances the internees in the motor pool had toward the administration, and a strike ensued that spread to the agricultural workers as well. Only a neutral investigation

Billy Manbo with his maternal grandparents, Junzo (left) and Riyo Itaya.

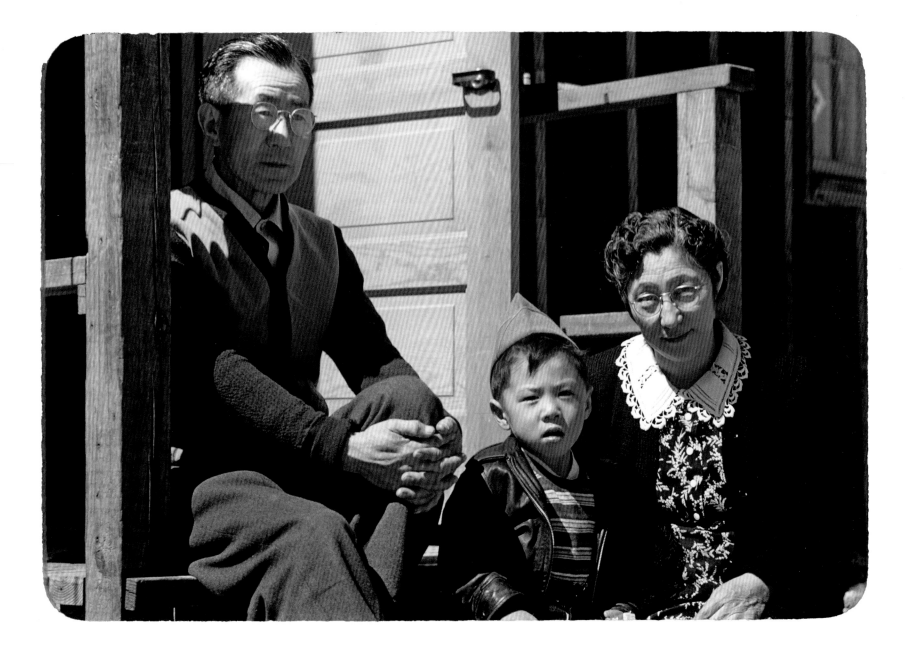

coupled with threats of reprisal against the striking workers averted what the camp's Project Attorney called "a crisis which would undoubtedly have resulted in calling [in] the military police and probably bloodshed."[21]

It was possible to leave camp, at first temporarily and later indefinitely, but it was never easy. As early as the fall of 1942, several hundred inmates were granted temporary passes (called "leave") to harvest the region's sugar beet crop, much of which would otherwise have rotted in the fields due to wartime manpower shortages. A small number of Nisei were granted leave at around the same time to attend college in the country's interior, and a few were quietly recruited into the army's Military Intelligence Service to serve as interpreters and interrogators in the Pacific theater. Sammy Itaya and a friend got temporary leave to work as pin setters at a Cheyenne, Wyoming, bowling alley for a few weeks in December 1942, but they were back behind Heart Mountain's barbed wire by Christmas.

Early in 1943, government policy began to shift toward encouraging (and even pressuring) some of the inmates to leave camp indefinitely rather than temporarily. This came about for two reasons. First, the military, which had reacted to Pearl Harbor by shifting all of the Nisei into the draft classification for aliens and other undesirables, decided that it wanted to recruit an all-Nisei force to fight in the European theater. Second, the WRA, overwhelmed by the size of its captive population and fearful of instilling long-term dependency on the government, decided that it wanted to scatter the inmates across the nation's midsection through a process it called "relocation." Both the military and the WRA

understood that they could not expect the rest of the country to accept the Nisei as soldiers or neighbors until they could attest to their loyalty. This led them to undertake a program of mass loyalty interrogations in the camps that would antagonize the inmates and, ironically, lead many of them, including Bill and Mary Manbo, to expressions of protest and acts of resistance.[22] Of the WRA's ten camps, Heart Mountain was the site of the best-organized dissent. Though that movement does not appear on the surface of the photographs that Bill Manbo shot in 1943 and 1944, it was their off-camera backdrop.

The trigger was a loyalty questionnaire that all inmates older than sixteen were forced to fill out in the late winter of 1943. The four-page form asked thirty-three personal questions about such things as the inmate's residential history, reading preferences, connections with Japanese language and culture, and financial situation. The most controversial questions were Number 27, which asked a male inmate whether he was willing to serve in the U.S. Armed Forces and a female whether she would be willing to serve in the Army Nurse Corps or the Women's Army Corps, and Number 28, which asked the Nisei whether they were willing to foreswear allegiance to the Japanese emperor in favor of allegiance to the United States and the Issei whether they would promise to take no action to interfere with the war effort.[23]

The effect of this interrogation on the inmates at Heart Mountain and the other WRA camps was corrosive. It became a lightning rod for the stress, insecurity, and resentment that had built up in the community over what was by that point nearly a

year of forced exile and detention. Simply being required to complete a form captioned "Application for Leave Clearance" was unsettling to people who had lost everything, were forbidden to return to their communities on the West Coast, and had nowhere else to go. Many feared that the questionnaire was an attempt to trick them into agreeing to be turned out of camp.[24] Most Nisei men had little interest in volunteering into the military, either because they resented incarceration or service in a racially segregated battalion, or because they did not wish to leave their vulnerable parents and siblings behind in camp.[25] They worried that Question 27 was tricking them into volunteering. And with its insinuation that the Nisei owed an allegiance to the Japanese emperor that they needed to foreswear, Question 28 insulted most everyone.

Rather than producing masses of army volunteers and lots of enthusiasm for relocation, the loyalty questionnaires mostly produced dissension and protest. A group of about 500 Nisei at Heart Mountain more or less spontaneously gathered to demand the suspension of the program to give the inmates a chance to think through and clarify the questions. An ad hoc "Congress of American Citizens," made up of self-appointed representatives from each residential block, convened and urged all Nisei to refuse to answer the questions until the government "clarified" their rights as U.S. citizens. As a process that was supposed to last days dragged into weeks, camp administrators grew impatient and began threatening anyone impeding it with prosecution under the federal Espionage Act. These threats did little to counter what one government official would later call "the mortality of loyalty"

occasioned by the questionnaires. Ultimately, the process at Heart Mountain in February 1942 produced only forty-two military volunteers out of the more than 1,700 men who were eligible. Almost one in four of the draft-age men answered "no" to Question 28. Three hundred twenty-nine Nisei filed requests for "expatriation," or abandonment of their American citizenship in favor of transportation to Japan.[26]

Bill Manbo made only two photographs of an event showing traces of the tension and upheaval occasioned by the loyalty questionnaires. One of these is on page 13, in which a crowd of inmates, some of them with luggage, tightly masses around the high school complex on a brilliantly sunny day.[27] This image, which Manbo took in the early afternoon on Tuesday, September 21, 1943, shows the sending-off ceremony for 434 Heart Mountain inmates who, as a consequence of their negative answers to the loyalty question, were about to be shipped to the Tule Lake Segregation Center in northeastern California. Until that point, Tule Lake had been a camp like the other nine WRA centers, but the government decided in the summer of 1943 to convert it to a segregation facility for those from all ten camps who had failed its loyalty test. Earlier that morning, a train had arrived from Tule Lake bearing 431 "loyal" inmates from that camp who were being shifted to Heart Mountain. At around three in the afternoon, after the send-off ceremony pictured in the photograph, the "disloyal" from Heart Mountain boarded the same train bound for Tule Lake. "While many waved goodbye," noted the *Heart Mountain Sentinel*, "others were seen weeping."[28]

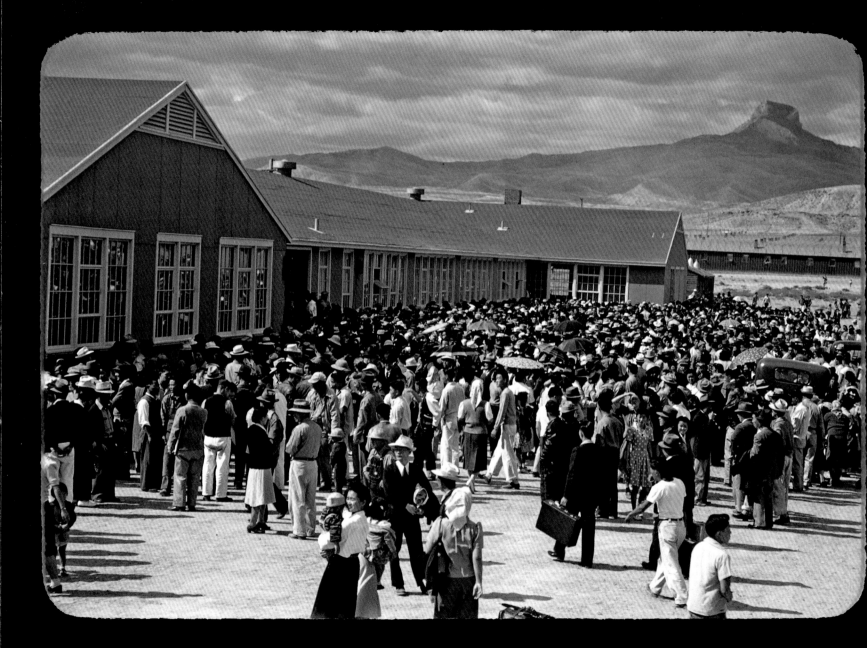

At midday on September 21, 1943, a crowd of about 4,000 gathers at the high school to send off 434 prisoners departing for the Tule Lake Segregation Center in California after the government deemed them "disloyal."

Bill and Mary Manbo's answers on their loyalty questionnaires did not put them on that train, but they did reveal anger and disaffection. Asked to indicate his wife's citizenship, Bill Manbo wrote "American?" with a question mark; he replied "not yet" to the question about whether he had applied for expatriation. He answered the question about military service with an outright "no." And to the question about his willingness to swear American allegiance and foreswear loyalty to Japan, he answered with an equivocation rather than a straight yes or no: "If we get all our rights back. Who wants to fight for a c.c. camp?"

Mary Manbo's indignation burned even brighter than her husband's. In the space for her citizenship, she wrote "U.S. at present[;] am doubtful of it." In the space for her husband's citizenship, she wrote "US?," and in the space for her husband's race, she wrote "Japanese. No fault of our own. Am very proud of my race." In response to the question of whether she had ever sent any of her children to Japan, she snapped, "No, what for?" She answered the question about her willingness to join the Army Nurse Corps or WAC with a question of her own: "Yes, but why was a friend of mine who is [a registered nurse] refused by the army when so many are needed?" To Question 28, which asked her whether she was loyal to the United States, Mary answered "yes" in the little space provided, but then added "I'm a born citizen," as if to emphasize that the question was unnecessary.

These answers got Bill and Mary Manbo into some trouble. In early August 1943, an official at WRA headquarters in Washington, D.C., issued formal requests to the project director at Heart Moun-

tain to "make further investigation" of both Bill and Mary Manbo because their answers to Question 28 were "qualified in such a way as to raise a question of [their] sympathies or loyalties" and because Bill had, as they saw it at least, indicated interest in expatriating to Japan.

Bill and Mary were called in for separate sessions before the loyalty hearing board at Heart Mountain on October 5, 1943. Two white WRA officials—the camp's attorney and its employment officer—handled the interrogations. They did not give Mary Manbo a particularly rough time. They read her answer to Question 28 back to her and asked her again whether she was willing to swear allegiance to the United States. "Well, absolutely," she replied. "After all, I was born here. I'm a little bit on the hot-tempered side so I suppose I say things I shouldn't." Given the choice, they asked, would she choose American or Japanese citizenship? She said, "The one I have," explaining that "I don't know the country over there. I was born and raised here. I've lived with Caucasian people all my life, and I wouldn't have any reason for wanting to go there." Consistent with the WRA's policy to try to relocate as many Nisei as possible, the interviewers probed her willingness to leave camp. She told them that she had no plans to leave because of her little son Billy: "If I didn't have my youngster, I would probably be gone, but the youngster is so small, I hesitate going out."

The interviewers were tougher on Bill Manbo in his hearing, in part because he did not make much effort to hide his anger over how he and his family had been treated. He told them that his feelings toward the United States had not been good when

he and his family had been forced out of California. "Being a citizen and everything," he told them, "I thought it was a raw deal." He told the interviewers that he would serve in the military only if he was drafted or no longer in camp. He did not "like the idea of the all-Japanese combat unit" and did not want to be relegated to menial work like "tak[ing] care of the yard or sweep[ing] the barracks or something like that." And he could not imagine going into the service while his family remained stuck behind barbed wire: "I would rather see them in a home first and then be drafted," he said.

The interviewers also zeroed in on Manbo's ambivalent answer to the loyalty question. How would he feel, they asked him, if he knew that his equivocal answer would mean he would have to stay in camp "for the duration"? When he replied that he had a decent job in the camp's motor pool and could see himself staying in camp, they were not satisfied and pressed for a definitive answer: "How would you like to have this question read?" they asked. "Would you want that to be 'Yes?'" "Sure," Manbo replied, "but I thought that stuff was . . . a medium of expressing your thoughts, wasn't it? The freedom of speech, wasn't it?" An interviewer responded bluntly: "Well, that may be to express yourself," he said, "but there is only one way you can express loyalty and that's 'Yes' without any conditions."

As the interviewers had done with his wife, they also pressed Bill Manbo about his willingness to relocate out of camp. Manbo was reluctant for a simple reason: he was an auto mechanic, and he had been forced to leave his tools behind in California. He had repeatedly asked the WRA to ship him the tools in camp, but it was against WRA policy to allow inmates to receive such items. The interviewers dangled in front of him the prospect that he could get his tools if he would leave camp, but Manbo responded that no employer would be willing to offer a job to an auto mechanic with no tools. It was a catch-22: he would only be allowed to receive his tools if he left camp, but he believed he could only find a way out of camp if he had his tools. The hearing ended with a vague promise from the interviewers that they would send Manbo's request for his tools to Washington and let him know what action to take.

These were the tensions and complexities in Bill Manbo's life as he wandered around camp in 1943, shooting pictures of judo matches and pickup baseball games, school parades and Bon Odori processions, drum majorettes and kimono-clad dancers. With this context, it becomes difficult to see Manbo's work as just an amateur photographer's snapshots of lively and colorful events. They begin to look much more like a documenting of Manbo's ambivalence about his own identity, the photographic equivalent of the question marks he and Mary placed after the words "American" and "US" when asked to report each other's citizenship on their loyalty questionnaires.

In the end, the WRA adjudged both Mary and Bill Manbo to be loyal to the United States. In February 1944, a review panel at the WRA's headquarters found Mary to be "a very Americanized individual" who was "angry to think that her loyalty [had] even [been] questioned" and whose answers on the loyalty questionnaire were "civil rights protests rather than disloyal comments." The same panel

concluded that Bill was "an outspoken, frank individual," who was "bitter because of the evacuation" but was "not as bitter as he once was." On March 30, 1944, the WRA officially granted "leave clearance" to both Bill and Mary—the official stamp of approval for relocating out of camp if they wished and were able to find a place to go.

By that point, the atmosphere at Heart Mountain was even more tense than it had been a year earlier when the loyalty questionnaires were administered. In late January 1944, the military announced that it would begin drafting Nisei men out of the WRA camps to fight with the segregated Nisei combat team in Europe. This decision triggered a new round of controversy at all of the camps, but nowhere did it foment as much organized resistance as at Heart Mountain. A small group of Nisei men organized themselves as the Fair Play Committee and began holding meetings in mess halls around camp in early February at which speakers condemned the illegality of their removal and incarceration and demanded the restoration of their rights as U.S. citizens. By early March, the Fair Play Committee had scores of members, was posting circulars throughout camp urging the restoration of citizenship rights as a precondition for conscription, and was publicly debating the legality of the draft with a more conservative Nisei faction in letters to the editor of the camp newspaper.[29]

The Fair Play Committee's position was not just talk: throughout March 1944, young men began refusing to show up for induction or for their preinduction health examinations. Eventually more than eighty-five young men would resist the draft at Heart Mountain. All of them would be arrested for draft evasion, tried in federal court, and sentenced to prison.[30] Bill Manbo, who was already in his mid-thirties and had a young son, was never drafted; he was spared the difficult decision about how to respond to conscription. But the anger he expressed on his loyalty questionnaire in February 1943 and in his interview in October 1943 is certainly consistent with the mood of the Heart Mountain Fair Play Committee.

At the same time, however, Bill Manbo had a reason to support military service: his brother-in-law was in the U.S. Army. In February 1943, Sammy had been ambivalent about military service. On his loyalty questionnaire, he had written that he would serve in the army only "if my citizenship status is clarified by Supreme Court + Congressional Act— And if I am allowed to volunteer for any branch of service." But in time he changed his mind. After passing the loyalty test, Sammy left camp in March 1943 for Barrington, Illinois, to do farm labor. After a few months there, he decided to enlist in the service and was assigned, after schooling, to duty in the Military Intelligence Service. Perhaps it was his Uncle Sammy's service that led Mary and Bill to dress Billy in a military uniform in so many photographs.

The issue of military service was complex in many families, with people responding in different ways to the government's demand that young men go off to fight for freedom while their own families were stuck behind barbed wire. Bill Manbo's photos and his and Sammy's answers on their loyalty questionnaires suggest that the issue was tricky for the Manbo and Itaya families as well.

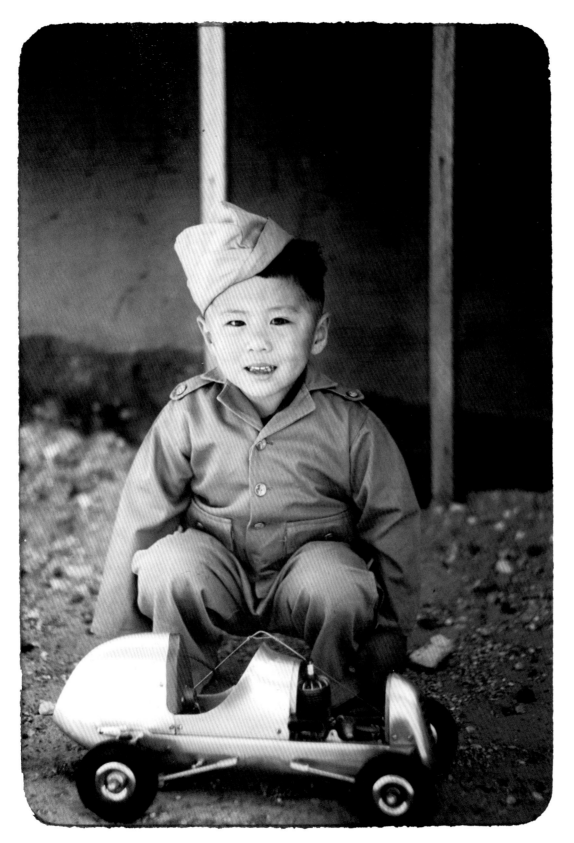

Billy Manbo poses in his soldier outfit with his father's model racing car.

The issue of relocating from Heart Mountain to a new job and location was just as complex for most families, and the Manbo and Itaya families were no exception. Until January 1945, the West Coast was off limits to every person of Japanese ancestry, so the only choice was to head off toward the East and the unknown. For the adventuresome, the prospect of relocation offered release from the monotony and constraint of confinement. Relocation also offered a much-needed chance to earn a living and begin to recover from the economic devastation of their forced removal and confinement. Junzo and Riyo Itaya's financial situation was typical. By late 1944, they had spent the $300 they had managed to bring with them to camp in 1942. As a couple they had brought in an average of $26 per month in wages and clothing allowances for their labor in camp, but they estimated their monthly expenses at around $80 and were not making ends meet. Their son Sammy sent them $50 per month after he relocated for farm work in Illinois in March 1943, but that supplement stopped later that year when he entered the service. Clearly, if Junzo Itaya could find a job on the outside, this would put them on a firmer financial footing.

At the same time, relocation was an emotionally and logistically daunting venture. It meant surrendering the predictability of life in camp and striking off for parts unknown with not much more than the clothes on one's back. It meant distancing oneself further from what used to be home on the West Coast. It meant confronting the anti-Japanese prejudices and hostilities of white communities and employers. And it meant leaving family and friends behind in camp to uncertain futures.

By the fall of 1944, Junzo and Riyo Itaya decided that the time had come to try relocating. Sammy had been gone for more than a year, and their youngest child, Eunice, had also relocated to Chicago to work for a mimeograph company when she turned eighteen in 1943. Of their children, only Mary remained at Heart Mountain, but their son-in-law was looking for work outside camp as well, and the Issei couple saw that it was only a matter of time until they would be all alone. Junzo left camp on November 9, 1944, to travel to New Jersey for a job interview at Seabrook Farms, a large operation that was recruiting Issei and Nisei workers from the WRA camps. Seabrook offered him the job in mid-November, and Junzo promptly returned to Heart Mountain to pick up Riyo for the move to New Jersey.

But he found Riyo unable to travel. In his absence she had suffered a nervous breakdown. Bedridden, she was beset by dizziness and severely elevated blood pressure and was vomiting frequently. A camp doctor diagnosed her as a "hypertension and neurasthenic case" and recommended prolonged bed rest. She had to quit her mess hall job, and Junzo abandoned the plan to relocate to New Jersey. He stayed in camp to care for her, but her condition lingered. Ten months later, in late September 1945, she continued to suffer from symptoms of what a camp physician termed "psychoneurosis": she was irritable and could not stand noise, her head pounded all the time, she had little appetite, and she slept poorly.

By that late point, the war was over and the West Coast had been reopened to Japanese Americans. Junzo and Riyo Itaya were all alone. Their

children Eunice and Sammy had left camp in 1943. Bill Manbo had left camp for factory work in Cleveland in November 1944, and Mary and Billy had joined him there in July 1945. As the camp closed and its remaining residents were forced out, the destitute Issei couple had only each other and the hope that they might return to their rhubarb crop in California to piece their lives back together.

It was then that the full extent of their loss became clear to them. They learned that Paul Wilson, the man in Norwalk they believed to be their landlord, had defrauded them. He had contracted to care for the family's rhubarb crop during the war and return it to them at war's end, but it turned out that he had been lying about everything. He did not even own the land he had been renting to the Itayas. He had lost it to the state of California in 1937 for nonpayment of taxes, but because the state had not demanded possession until January 1943, Wilson had been able to collect years' worth of rent from the Itayas without any legal entitlement to it. Within months of the Itaya family's forced removal in 1942, he had allowed their rhubarb crop to be plowed under and destroyed. Even the two movable buildings on the land that the Itayas owned were gone without a trace. It was a complete loss for the aging couple; there was no life left in Norwalk for them to return to.

Bill, Mary, and Billy Manbo stayed in Ohio until 1946, when a back injury made it impossible for Bill to continue factory work. They returned to California, eventually settling back in Hollywood, where Bill reopened his garage and Junzo and Riyo moved in with them. Junzo tinkered with machines in the garage, designing an automated fishcake maker that was installed in a shop in Little Tokyo. For a time after the war, Bill and Mary would invite friends over to watch Bill's color slides and reminisce about life at Heart Mountain. But this ended after a few years. The slides were boxed up and stored away like the memories they captured.[31]

Billy Manbo—known outside his family as "Bill"—graduated from Hollywood High School, his father's alma mater, in 1958. He joined the Air Force, serving with a weather squadron until 1962. After that he trained as a mechanic at a trade school in Illinois and took up the sport of skydiving. Through skydiving he found work doing rigging and testing for parachute companies, which in turn led to a position designing emergency aircraft escape systems for the Douglas Corporation. Later in his career he worked as an aircraft dispatcher for Jet American Airlines and in flight operations for Boeing. He remained an avid skydiver for years, racking up more than 1,150 free falls before giving the sport up due to injury.[32]

Now in his early seventies, Bill Manbo, the photographer's son, maintains that his time behind barbed wire left him unscarred, other than a small burn on his leg from jumping into a pile of coal embers at the end of his barrack. It seems doubtful that his parents or grandparents could say the same. Imprisonment at Heart Mountain interrupted their lives, stripped them of property and plans, led them to question their identities, cast them tightly together and flung them apart.

This vortex is not what Bill Manbo tried to document with his camera and Kodachrome. He did something closer to the opposite. In his landscape shots and his pictures of festively clad dancers,

wrestlers, and marchers, he searched for beauty and excitement in his surroundings and might be understood as looking through the camera's viewfinder to find refuge from the pressure and monotony of confinement. His family photos work against the vortex even more obviously: he used his camera to draw his family together, shoulder to shoulder, to document some semblance of an ordinary life in extraordinary circumstances, and to create for his young son a visual legacy of a normal childhood.

The publication of these photographs might discomfort some Japanese Americans. Some may worry that photos of joy and beauty behind barbed wire will stoke old claims that Japanese Americans "had it good" in camp. Others may fear that photos of imprisoned Japanese Americans wearing Japanese attire and participating in Japanese cultural activities will revive old allegations that the community was "disloyal." But a moment's reflection—and the sad arc of the family's story as I have told it here—should show that these concerns are no deeper than the surface of the paper on which the images are printed.

NOTES

1. The Evacuee Case Files are in Record Group 210 at the National Archives and Records Administration's facility in Washington, D.C. Record Group (RG) 210 contains the records of the War Relocation Authority (WRA). The Evacuee Case Files contain a surprisingly wide range of documents and information about individual Japanese and Japanese Americans in WRA custody, including their school, health, and employment histories while incarcerated, their comings and goings from camp, their answers on a loyalty questionnaire, records of security inquiries by the WRA and other agencies, and transcripts of loyalty interrogations.

2. United States Code, Title 8, §359 (Washington, D.C.: U.S. Government Printing Office, 1926).

3. Evacuee Case Files of Junzo and Riyo Itaya, RG 210, National Archives, Washington, D.C.

4. Robert M. Jiobu, "Ethnic Hegemony and the Japanese of California," *American Sociological Review* 53, no. 3 (June 1988): 353–67. Many Issei managed to evade the strictures of the alien land laws by titling their land or executing rental agreements in the names of their children, who as U.S. citizens were outside the reach of the restrictive laws. This was Junzo Itaya's strategy; he rented the land he farmed in the name of his son Sammy.

5. Eiichiro Azuma, "The Pacific Era Has Arrived: Transnational Education among Japanese Americans, 1932–1941," *History of Education Quarterly* 43, no. 1 (Spring 2003): 39–73; Eiichiro Azuma, *Between Two Empires: Race, History, and Transnationalism in Japanese America* (New York: Oxford University Press 2005), 145–51.

6. There are no truly reliable estimates of the number of Kibei. See Roger Daniels, *Asian America: Chinese and Japanese in the United States since 1850* (Seattle: University of Washington Press, 1988), 176.

7. David Yoo, *Growing Up Nisei: Race, Generation, and Culture among Japanese Americans of California, 1924–49* (Champaign: University of Illinois Press, 2000), 28–29.

8. The "T" was for his given Japanese name, Takato. Like most Nisei, he went by his American name ("Bill"), though his yearbook photograph from Hollywood High School lists the nickname "Tak."

9. Biographical information comes from documents in Bill Manbo's Evacuee Case File in RG 210 at the National Archives in Washington, D.C., and from the 1928 issue of the Hollywood High School Yearbook, *The Poinsettia*, which is available online at http://4dw.net/socal/1928hhsw29.html.

10. Mary's given Japanese name was Kimi.

11. Biographical information on Mary Manbo comes from documents in her Evacuee Case File in RG 210 at the National Archives, Washington, D.C.

12. Billy's given Japanese name is Takao.

13. This figure is derived from the tabulations of the War Relocation Authority, which reflect that of the entire incarcerated population in late 1942, just 8.2 percent had two parents born in either the United States or Hawaii. See War Reloca-

tion Authority, *The Evacuated People: A Quantitative Description* (Washington, D.C.: U.S. Government Printing Office, 1946), 89.

14. Tetsuden Kashima, *Judgment without Trial: Japanese American Imprisonment during World War II* (Seattle: University of Washington Press, 2003), 14–42.

15. Enemy Alien File for Junzo Itaya, Number 146-13-2-12-1585, RG 60, National Archives, Washington, D.C.

16. As Jasmine Alinder's contribution to this book indicates, Japanese Americans were initially forbidden to have cameras. This prohibition was not relaxed at Heart Mountain until the spring of 1943. We do not know whether Bill Manbo left his camera in someone else's care when he was evicted from the coast and then sent for it in 1943, or whether he spirited it away in his luggage in April 1942 and brought it into camp with him as contraband.

17. The documents relating to the Itayas' rhubarb crops and their efforts to hold on to them while imprisoned are in Sammy Itaya's Evacuee Case File, RG 210, National Archives, Washington, D.C.

18. The Santa Anita Assembly Center is described more fully in J. Burton et al., *Confinement and Ethnicity: An Overview of World War II Japanese American Relocation Sites* (Washington, D.C.: National Park Service, 1999), available online at http://www.cr.nps.gov/history/online_books/anthropology74/ce16k.htm.

19. On the Santa Anita riot, see Roger Daniels, *Concentration Camps USA: Japanese Americans and World War II* (New York: Holt, Rinehart, and Winston, 1971), 106; and Harry H. L. Kitano, *Japanese Americans: The Evolution of a Subculture* (New York: Prentice-Hall, 1976), 73.

20. Although now thirty-six years old, Douglas W. Nelson's path-breaking *Heart Mountain: The History of an American Concentration Camp* (Madison: State Historical Society of Wisconsin, 1976) remains the best history of the camp. Also excellent is Mike Mackey's *Heart Mountain: Life in Wyoming's Concentration Camp* (Powell, Wyo.: Western History Publications, 2000).

21. Letters, Jerry W. Housel to Lewis Sigler, April 29 and May 6, 1943, RG 210, Entry 16, Box 267, National Archives, Washington, D.C.

22. On the development of the loyalty interrogation program, see Eric L. Muller, *American Inquisition: The Hunt for Japanese American Disloyalty in World War II* (Chapel Hill: University of North Carolina Press, 2007), 15–30.

23. Ibid., 31–38. Initially, the form asked the Issei to answer the same version of Question 28 as the Nisei; that is, it asked them whether they were willing to renounce their allegiance to Japan—and thereby render themselves stateless. An outcry among the Issei quickly led the government to change the wording of Question 28 for the Issei so that it asked them only whether they were willing to promise not to cause trouble. See ibid., 35.

24. Junzo Itaya shared these fears; he volunteered on his questionnaire that "this application does not evidence my desire to leave the relocation center at this time."

25. Sammy Itaya, for example, answered question 27 with these words: "Yes—if my citizenship status is clarified by Supreme Court + Congressional Act—And if I am allowed to volunteer for any branch of service."

26. Eric L. Muller, *Free to Die for Their Country: The Story of the Japanese American Draft Resisters in World War II* (Chicago: University of Chicago Press, 2001), 54–56.

27. The other photograph, nearly identical, is not reproduced in this book.

28. "Thousands See Segregees Off," *Heart Mountain (Wyo.) Sentinel*, Sept. 25, 1943, 1.

29. Muller, *Free to Die for Their Country*, 64, 76–82.

30. Ibid., 84–99, 108–14, 161–75.

31. Takao Bill Manbo, interview by author, Los Alamitos, Calif., July 19, 2010.

32. Ibid.

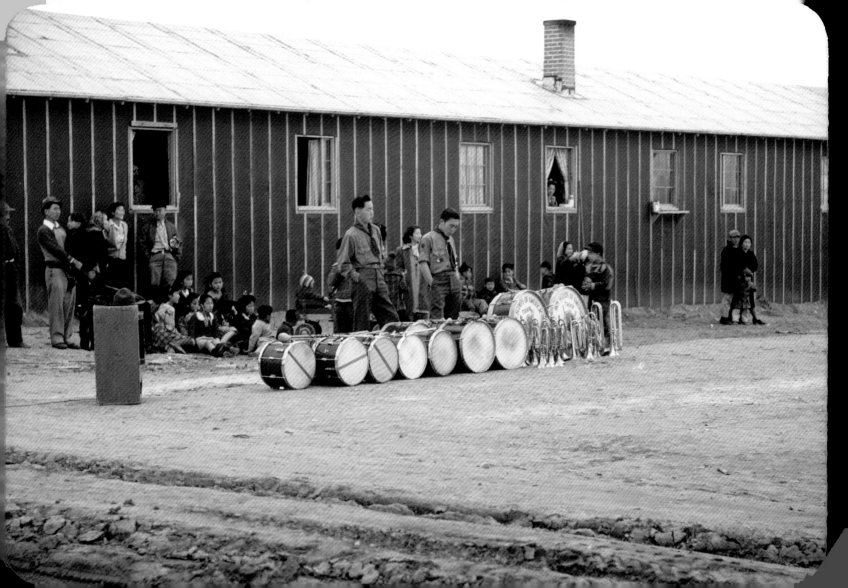

A Youngster's Life behind Barbed Wire

BACON SAKATANI

When Bill Manbo was incarcerated at Heart Mountain, he liked to take pictures of kids. There are pictures of kids playing ball, swimming, ice-skating, marching in parades, dancing in Bon Odori, shooting marbles, and doing lots of other fun things. I was a kid at Heart Mountain, too, about ten years older than Bill Manbo's son. I don't think I am in any of the photos, but I easily could have been, because I remember doing all of those kinds of activities. Bill Manbo and his wife Mary are no longer alive to tell their own stories of life in camp, and their son was too young to remember much of anything. Maybe the story of my life at Heart Mountain can shed light on what it was like to be a kid there and what it meant to "have fun" in captivity.

I was born in 1929 in El Monte, California, east of Los Angeles. My father, an Issei, came to the United States with his parents in 1915. My grandparents returned to Japan after World War I ended, but my father stayed here, working as a "haul man" who trucked vegetables from Japanese-owned farms to the wholesale market. He went back to Japan to marry my mother, brought her to the United States, and started vegetable farming in El Monte. Two boys and a girl came along before me, and my younger sister was born a few years after me.

Late in the 1930s we moved to La Puente for newer farmland. This was an area with many Japanese vegetable farmers and a few wholesale and retail plant nurseries, flower growers, and citrus farmers. A few Japanese had grocery stores, fish markets, barbershops, and, like Bill Manbo, car repair shops. On our farm, the main crops were raspberries, cauliflower, cabbage, romaine, brown onions, and cantaloupes. We also grew rhubarb like the Itaya family did. My parents belonged to the Hiroshima Kenjinkai, a group of Japanese immigrants from Hiroshima prefecture in Japan, as well as a local Japanese farmers' association. They would have picnics at parks and beaches or rent a school auditorium to show Japanese movies.

From the first through the fifth grade in El Monte, my siblings and I attended a segregated grammar school for Hispanics and Japanese; from the sixth grade on, we attended the normal schools in El Monte and in La Puente. When I was about ten years old, I started going to an all-Japanese judo school once a week along with my older brothers.

We learned Japanese wrestling there and kept going until the school was closed down shortly after the beginning of World War II with Japan. We also attended a Japanese-language school once after regular school during the week and on Saturdays. I learned simple Japanese writing and speaking skills, but I mainly learned the language through conversing with my parents, and I would say I was poor in my Japanese-speaking ability. Our Japanese school would have annual events where the students would put on skits and give speeches in Japanese to show our parents what we were learning. Most students hated doing this, as it consisted of memorizing things we did not quite understand.

I could see that the economy prior to World War II was picking up, as more and more Japanese families were getting new cars, trucks and tractors, electric cooking ranges where natural gas was not available, and electric refrigerators to replace the "ice box" with its daily delivery of ice blocks. Boys my age were getting new, sporty bicycles, and I knew I would be getting mine soon. My eldest brother, a senior in high school, got himself an old Ford convertible jalopy, fixed it up, painted it, and had a new canvas top put on so that he could participate in after-school sports and come and go as he pleased. My retired Caucasian neighbor was now working one day a week and was paying me a nickel for feeding his chickens while he was gone. My parents got my eldest sister a piano, and an instructor—a Japanese, of course—was coming every week giving lessons.

Then on Sunday, December 7, 1941, my eldest sister heard on the radio that war had started between the United States and Japan with the bombing of Pearl Harbor. She went out into the field where my father was working and told him the news. My mother put away all of the Japanese items in our house but left the portrait of President Lincoln out.

Soon after the war started, a few of the Issei in our area got picked up by the FBI as possible risks to the security of the United States. One day a few months later when my father was out, FBI agents came to our house, rummaged around, and told us to have our father report to the police station when he came back. He reported to the police station as directed and, like Junzo Itaya, was taken to the Tujunga Internment Camp about twenty miles away and then later to the Justice Department internment camp in Santa Fe, New Mexico. We didn't see him again until he was released in July 1942.

My eldest brother, a high school senior, had to quit school to help run the farm and take the harvested vegetables to the wholesale market at night. Then in the spring of 1942 the "evacuation," area by area, of all persons of Japanese ancestry into assembly centers began, so we had to start to dispose of our farm as best we could before the removal orders came to our area. On May 9, 1942, cardboard posters appeared on telephone poles and walls of buildings informing us that "all persons of Japanese ancestry . . . both alien and non-alien . . . w[ould] be evacuated [on] May 15, 1942." The instructions said that the "size and number of packages [wa]s limited to that which can be carried by the individual or family group."

So with this six-day notice, suffering a tremendous loss of property, we reported to the local assembly area and were taken to the nearby Po-

mona Assembly Center, located at the Los Angeles County Fairgrounds. We took only what we could carry, and the only thing I remember I took was the new leather jacket my mother bought me for the trip. We were placed in tarpaper-covered army-type barracks in a room around twenty feet by twenty feet for our family of six. (My father was still incarcerated at Santa Fe when we arrived at Pomona.) We were each given canvas bags, and we filled them with straw for our mattresses on army cots. There was a high chain-link fence with guard towers around the camp, making it impossible to escape. There were 5,500 of us in the camp, and there were only three mess halls, or cafeterias, to feed us, so long lines formed way ahead of the time the doors opened. Facilities that included both shower rooms and latrines were located throughout the camp. Schools were never set up at Pomona, so to keep the youths occupied, the authority started softball games, and I was able to get on a team and play the sport for the first time. Musicians got together and formed a band, a stage was built on open land, and weekly talent shows were held. We stood or sat on the dirt ground at first, and then folding chairs began to appear so that we could watch and enjoy the variety of talents within the camp.

A small group of young adult males stood out with their long Pachuco haircuts and their baggy pants with tight cuffs called "drape" pants. To be confined with over 5,000 Japanese persons in a small, very crowded area was a new experience for all of us, but I don't recall any type of protest being held or any talks of injustices among my younger group. A weekly mimeographed newsletter began to appear, written by those confined. I do not recall anything about how our family laundry was done, but it must have been done by my mother and eldest sister. Visitors from the outside were allowed, and our former landlord came once to see us, greeting us under the watchful eyes of the armed guards. A high school graduation ceremony was held at the racetrack stadium for those students who would have graduated, and my brother was among them.

Then in August of 1942, trainloads of people began to be shipped to Wyoming to a more permanent, isolated place called the Heart Mountain Relocation Center. I recall going through the desert of Southern California and through the states of Arizona, New Mexico, and Colorado, reading the signs with the names of the towns as we passed. I turned thirteen on that trip. We sat on hard seats and were ordered to pull down the shades as we passed through towns or approached oncoming trains.

When the train got near to Heart Mountain after three or four days, I remember seeing groups of white persons staring at us as we passed by. At the new camp of tarpaper-covered barracks, we were assigned to block 9, barrack 22, room E. The size of the room was twenty feet by twenty-four feet with open ceilings, a single lightbulb, a coal-burning stove, a mop, a broom, and a bucket. Each of us in our family of seven (my father was once again with us) was issued a steel army cot, a mattress, and blankets. With seven beds in the room, there was hardly room for anything else. Luckily, the mess hall and latrine–laundry room were close by. Construction of the camp was still going on, with piles of scrap lumber lying about, so we built our own makeshift furniture from the scrap. It was my duty to keep the coal bin full for the stove.

Ice-skating was a popular winter activity at Heart Mountain. Prisoners used fire hoses to create several skating areas around the camp. Here, in the middle of a crowd of skaters, Billy Manbo gets a lesson.

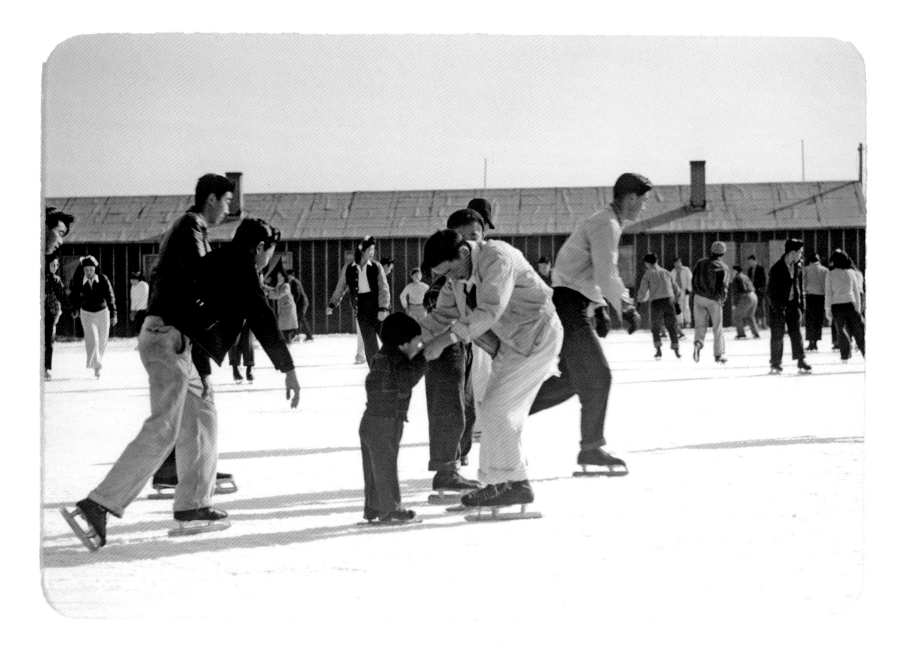

At the very beginning, families ate together at the mess halls, but groups soon formed and ate by themselves without their parents or family members. In the morning, I would wake up and go to the latrine, then have breakfast by myself or sit with any friend who happened to be there. As the youngest son of the family, it was my job to sweep and mop our room. After I did that, I had the rest of the day to fool around with my friends. Not being able to go outside the fence, our group of boys took cardboard boxes we found outside the mess halls and made shields out of them as we threw dirt clods at each other. We roamed around to see other parts of the camp, which now had 10,000 persons in twenty blocks. Once we roughed up the youngest member of our group, and before we knew it, a complaint from the boy's parents got us dragged into the police station for a bawling out by the police chief. Luckily, this was not reported to our parents.

Guard towers surrounded the camp, but they were manned only at night by armed guards with large searchlights. We were forbidden to go outside the fence. Snow came early in the fall, so we went to the scrap lumber pile to get lumber to make sleds, and I was fortunate to find metal package strappings to line the bottom of the sled so that it would slide down smoothly and faster. We went to the only hill just outside the fence to go sledding. The hill was full of youngsters. Many years later, I found out that one day, a group of thirty-two boys went sledding on that hill and military police guards came and hauled them away for violating the rule of being outside the boundary of the camp. What a scary moment that must have been for

them then, but now I wish I had been among them so that I would have that story to tell.

With the coming of snow, we made snowmen and had snow fights. There was an old grumpy man who did not like us young kids, so when he was walking away from us with his back to us, we threw snowballs at him and quickly ran around a corner of the barrack before he could see who threw them. Ice-skating rinks were made, which meant that all of the youngsters had to have skates. What a joy it was to learn to skate, but it must have been a terrible hardship on the parents to outfit all of their children with skates. The camp had no department store, so items like ice skates had to be ordered through the mail-order catalogs of Sears Roebuck and Montgomery Ward. Those companies did a tremendous business supplying the needs of the people confined in the camp.

A little later, we were allowed to go outside the fence so long as we stayed within the camp's outer boundary. We went hiking to the nearby hills, looking for squirrels, horned toads, and rabbits. Once I found a rattlesnake and smashed it with my hiking stick, breaking the stick with a sharp edge to cut off the snake's head. I now wish I had saved the rattler and the fangs! One of us even found a dreaded tick on his outer clothing. And then after a hot day out, we would go to the canteen, where we each treated ourselves to rare ice cream cones for five cents each, single-deckers.

Schools started in the fall of 1942, situated in barracks. I was in the eighth grade and remember the twenty-by-twenty-foot and twenty-by-twenty-four-foot rooms completely full of students, sitting on hard wooden benches. No desks, no books, no

blackboards—just a teacher. On cold days, those sitting next to the coal-burning stoves roasted while those in the far corners froze. The ceilings were open to the rafters, so noise from the other classes could be heard. I remember learning two new words in my eighth-grade classroom: *environment* and *adaptation*.

By the following school year, in the fall of 1943, a new school building was built, with a large gymnasium. In one of my classes, somehow things once got out of control and most of the students (but not me!) got very unruly. The teacher got upset and told us that we all had to write an essay on sportsmanship right then and there and turn it in before the class ended. I got an introduction to mechanical drawing at that school that I liked so much that I majored in that subject later when I attended a two-year college.

Our high school had a basketball team and would play outside schools at our gymnasium. The games were exciting to watch. Our football team played exceptionally well and in 1944 was the conference champion, beating all of the school teams from the surrounding white communities. The team would have gone to the state championship game had it not lost the final game.

Each residential block had two "recreation" buildings, which in reality were just 20-foot-wide, 100-foot-long barracks. One of the recreation buildings in my block had weekly Protestant church services, and I went to its Sunday school because my friends were going and because it satisfied one of my scouting requirements. All other days it was a regular recreation hall, and that is where I learned ping-pong and boxing. The other

recreation hall in my block was one of the camp's two movie theaters, with wooden benches, somewhat elevated in the rear, and dark curtains in the windows. They showed old movies, with newsreels and weekly serials at the beginning, one of which was *Flash Gordon*. Admission was five cents for children and ten cents for adults.

Sometime in 1943, realizing that the youngsters in camp did not have much in the way of recreation and were running around in groups and getting into trouble, camp authorities rounded up boys to form tackle football teams and supplied us with coaches. My team was the "Bulldogs," and for many of us, this was our first chance to play football. Later we formed softball teams.

An older Nisei became interested in our group of boys and taught us how to make gliders out of balsa wood. We would have competitions to see how long they would float in the air. He even taught us how to put propellers on them, twisting a rubber band to be the motor and then letting the planes loose to fly in the air for short durations. Then one day he said we should go to the nearby town so that we would not forget what it was like. We got our passes and boarded a bus to Powell, Wyoming, just twelve miles up the road. The one thing I remember about the town was the "No Japs" signs displayed in shop windows. That was the first time I saw them, and they really scared me. I was not quite fourteen.

Scouting was also strongly encouraged to keep us out of trouble, and just as with football, scouting leaders came to us to form troops. We became Troop 313. One of our first activities was camping. Two large army tents were put up just outside the

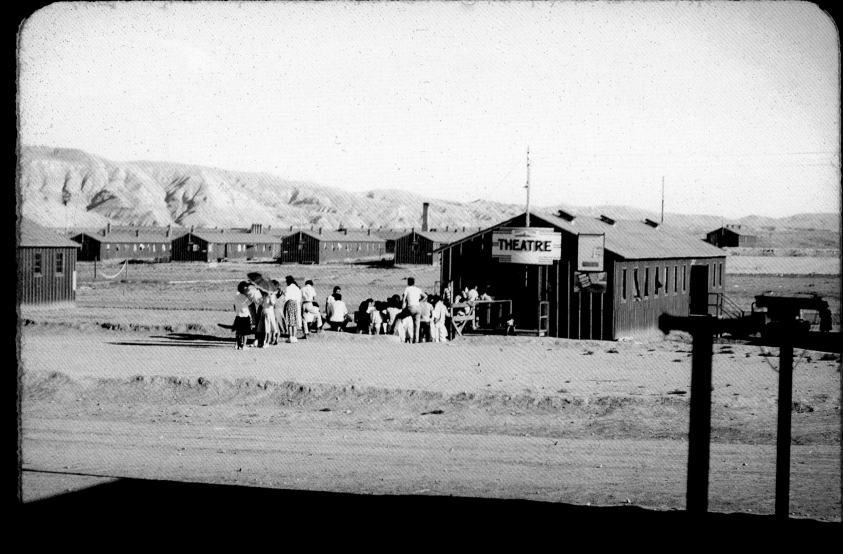

The splash of a diver can be seen in Heart Mountain's swimming hole, dug by prisoners in late July 1943.

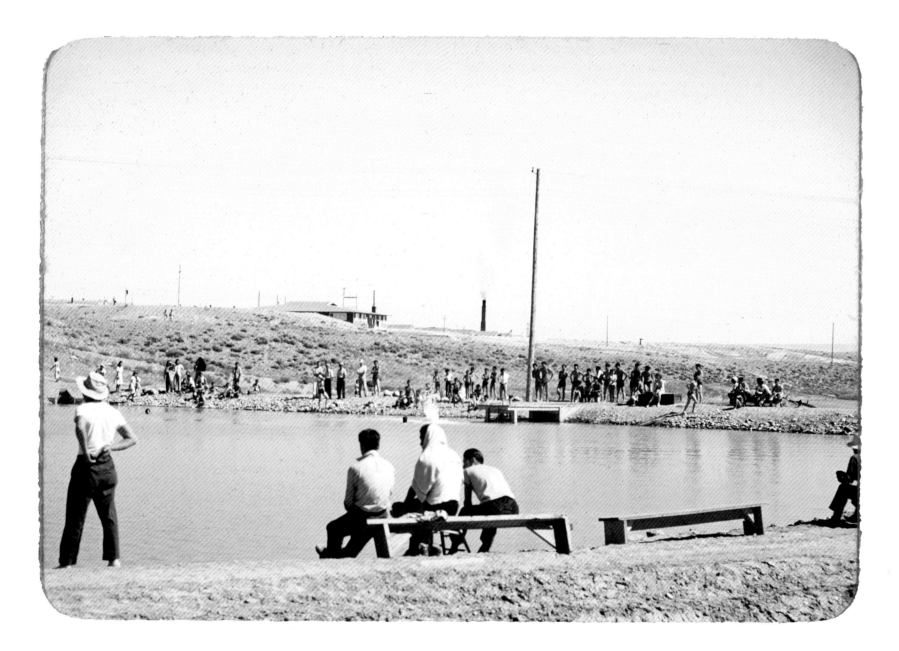

fence, cots were lined up inside, and some of our parents cooked meals for us. Our troop had a ping-pong tournament, and I finished in first place! A basketball league was formed within the scouts, and I led in scoring in the first few games but finished badly by the end of the season. At our troop meeting once, all of us were asked (forced) to put on a talent show. I had just learned how to play a simple instrument called the "tonette," so I accompanied several scouts who sang some scout song.

Scouting was a very interesting experience for all of the different things we learned, like to always "be prepared." We learned first aid, Morse code, and knot tying, some of which I remember to this day. A large hole filled with irrigation water became our swimming hole during hot weather. Usually the water was too cold because the water was melted snow coming from the high mountains, but I persevered and learned to swim there and passed my fifty-yard Scouting swimming test to attain the rank of First-Class Scout. I have to admit that for a novice swimmer, it was a scary event.

Later on, a group of us boys from my block decided to go camping at the nearby river. So we went to the mess halls and begged for wieners and loaves of bread, went through the side fence where there were no guards, through the six-foot concrete culvert underneath the highway, and through a deep ravine leading to the Shoshone River. We made tents from blankets. We saw a field of watermelons nearby, but we didn't know how tell if they were ripe enough to eat, so one of the boys got his pocketknife out and plugged it to check for ripeness. It was not ripe enough, and so we kept plugging

melons until we found one ripe enough and took it back to the camp by the river. Then we had a summer rainstorm, and our worried parents came looking for us and dragged us back to camp. In the following weekly camp news bulletin, I saw an article about the destruction of some of the camp farm's watermelon crop by reckless plugging. I feel very ashamed today of my part in that episode.

In the summer of 1944, Heart Mountain's director, feeling that the youngsters in the camp were too much under the influence of their Issei parents, decided to arrange a trip to nearby Yellowstone National Park for exposure to the "American way of life." Five hundred Boy Scouts, Girl Scouts, and Campfire Girls spent one week camping at Yellowstone. My father made me a fishing pole to use at the park, so I dug for worms and tried fishing during the day, but I couldn't catch anything, so I left my fishing line in the river overnight. The next morning, to my surprise, there was a trout on my line. I took the fish to the cafeteria and I don't know what happened to it. Many years later, I found out that leaving an unattended fishing line in the water is prohibited, and I didn't even have a fishing license. That trip was very memorable, as we were taken to view the various natural wonders of the park such as the Grand Canyon of the Yellowstone and the many hot geysers.

Also during the summer of 1944, I was able to work for one month at the camp farm harvesting peas. I was assigned to load freshly cut pea vines onto wagons with a pitchfork for threshing. It was not a solid eight-hour day of work, so there was lots of fooling around between loads with the other

"workers." I was paid twelve dollars for this work, and I really felt rich. I wish I could remember how I spent all that money.

In the men's latrine, the toilet bowls were lined up less than two feet apart, without partitions. Sometimes some of us boys would sit together and discuss what we would do that day. We would also have towel fights in the showers, where we would hold one end of a towel and snap it at another naked boy to see how badly we could sting each other. Once we took toilet paper, rolled it like a cigarette, and smoked it, but that was terrible, so we didn't do it again after our first try. It was better to have someone steal pipe tobacco from his father and "roll our own." Running to the latrine in the middle of the night in freezing, snowy weather was not pleasant, but we did not have a chamber pot in our room like some others did. Those were noticeable in the mornings as objects under cloth coverings that people would hurriedly carry. On snowy days, yellow spots would appear in the snow.

My father would sometimes leave camp on a temporary pass to do farm labor in the region. When he would return, he would sometimes sneak bottles of liquor into camp. In the spring of 1945, he somehow managed to sneak into camp the special rice for making wine. I helped him make special boxes to steam-cook the rice on top of the coal-burning stove and then put that in vats to ferment. Meanwhile, we made another box the size of an apple box with a small hole in the bottom and coated it with hot paraffin wax to make it waterproof. When the rice was properly fermented and so smelly that my sister stopped asking her friends over, we put the fermented mess in a canvas bag,

placed it in the waxed box, and put a weight on top so that clear liquid would pass through the canvas. The remains of the fermented rice were a very good preservative because of the high alcohol content, so my mother would get fresh salmon from the fish market at the camp and pickle them in the fermented remains. They made very tasty snacks! And I swear I never took a drop of the wine.

When it was time to leave the camp in 1945 after the war ended, we boarded a bus for Idaho, where my father had found a job picking potatoes. We kept quiet all the way there, as we had been told not to speak Japanese in public. Once in Idaho, there were other Japanese there so we felt comfortable, and I had few friends at the school. But when winter came and there were no more jobs for us, we boarded a train back to California, going meekly and quietly, as the train was full of returning servicemen in uniform. Somehow I felt like a defeated enemy in my own country, never to speak the Japanese language in public.

When we returned to California, we could not find a place to stay so my father bought a surplus army squad tent and put it up in the backyard of our former landlord, trying to get back our former farm across the street. He was not able to get our farm back, and all of the belongings we had left in our sheds were gone, but we found a farm in a nearby town.

At the new high school, my sister and I were the only persons of Japanese ancestry, so being as I am, I hardly got to know anyone and was a loner there. When I had to give a speech in one of my senior classes, the topic I chose was "I Am an American, Too," and I spoke about Heart Moun-

tain. I attended a community college for two years, and when the Korean War started soon after, I was drafted into the army and sent to Korea. Doing guard duty to protect everyone in the army base, I wondered if they knew I had myself been under U.S. Army guards in a camp during World War II. I didn't know the term *concentration camp* then.

For many years after our camp days, I assumed that what we went through was legal and the American way in times of war, especially when our parents were from the enemy side. Our struggles to cope with our circumstances after getting out of the camp were very difficult, and it is an area we hardly discuss because it is an embarrassing story to tell.

Sometime in the 1970s, a Japanese American woman came to our Japanese community center and spoke about the illegalities of the camps and the hardships suffered by all Japanese Americans who were sent to them. She said we should all do something about the injustices. In the frame of mind I was in at that time, I didn't know what she was talking about. I leaned over to the person next to me, a former internee of my age, and whispered, "What is this woman talking about—I had fun in camp!" and he agreed with me.

And then in 1981, I joined a group to help plan the first reunion of former Heart Mountain internees. I was assigned to give a slide show on the history of the camp, so I went to the local library to do some research because I really knew nothing except that I had been there. What I found out amazed me: that we shouldn't have lost our farm or been sent to Wyoming, that the suffering we went through after camp was not necessary. A govern-

ment commission affirmed this in 1982, concluding, after much study, that what happened to us was because of "race prejudice, war hysteria, and a failure of political leadership." The government backed that up with an official apology and a token redress payment to us under the 1988 Civil Liberties Act.

As I look back on my life as a kid at Heart Mountain, I know that I had fun, but I think about it differently than I used to. When the war started and we were forced into camp, most of us simply accepted this as what happens when your country goes to war with the country your parents are from. At first, the camp was tightly controlled by armed guards, barbed-wire fences, and guard towers with huge searchlights, but those controls were soon relaxed and we were allowed to wander outside the fence and even go shopping in nearby towns. We were allowed to have ice-skating, all kinds of sporting activities, and even Japanese cultural events. When the army wanted to withdraw its sentries from the perimeter entirely, they ended up staying only because the neighboring towns insisted on it.

Within the camp, we were no longer minorities. Many Issei, who had had no part in outside community affairs on the West Coast, were able to be fully involved. Adult classes in the English language and Japanese culture quickly formed, and because everything was within walking distance, older people were able to take advantage of them. Over time, the sting of their losses of freedom and property dulled, and they tried to enjoy what the camp had to offer while they waited for the end of the war.

The younger generation, even those still in school, would have had few leadership opportuni-

ties on the outside, but they now found themselves in control of community affairs. Japanese Americans would typically find themselves too small on the outside to compete at the varsity sports level, but in camp they had the opportunity to participate fully.

So Heart Mountain definitely presented us with certain kinds of opportunities. It turned out to be an "American-style" concentration camp, unlike those of Europe that confined Jews and others, where starvation and executions were the norm. We see the wrongfulness of our confinement clearly today, but the viewpoints and political thinking of those World War II days were different from what we now know. Civil rights violations were accepted as part of the American way of life, and it was not until forty years later that these wrongs were acknowledged.

It can be said that the camp experience was a source of fun and enjoyment for the kids and teens of those days. We were not the ones who lost our jobs, homes, businesses, and property; it was our parents who lost a lifetime of work and had to struggle to be accepted just as the economy was improving. This is not to say that our imprisonment was a good thing for us kids, but given the conditions that were unjustly forced on us, we accepted the situation and made the best of it.

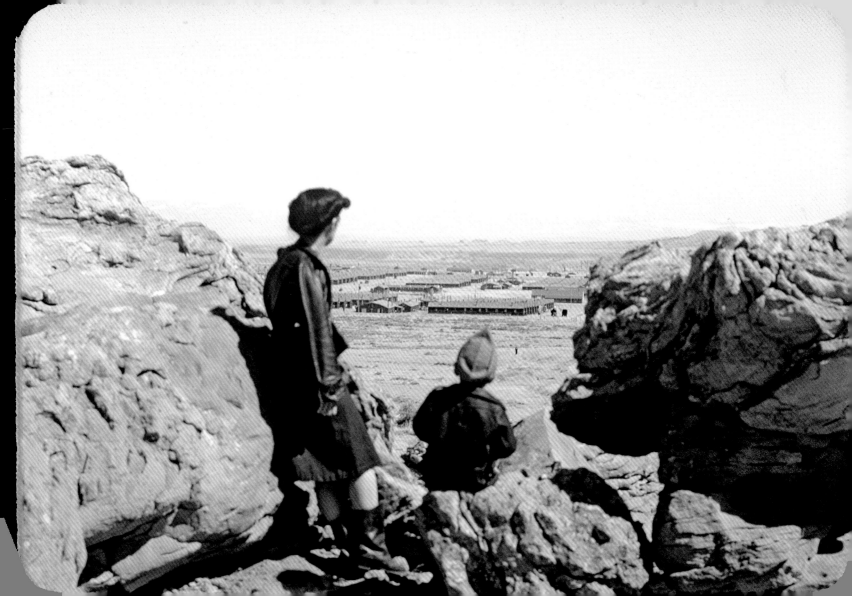

The view up Avenue E toward Heart Mountain. The light-colored building with the red roof is the high school.

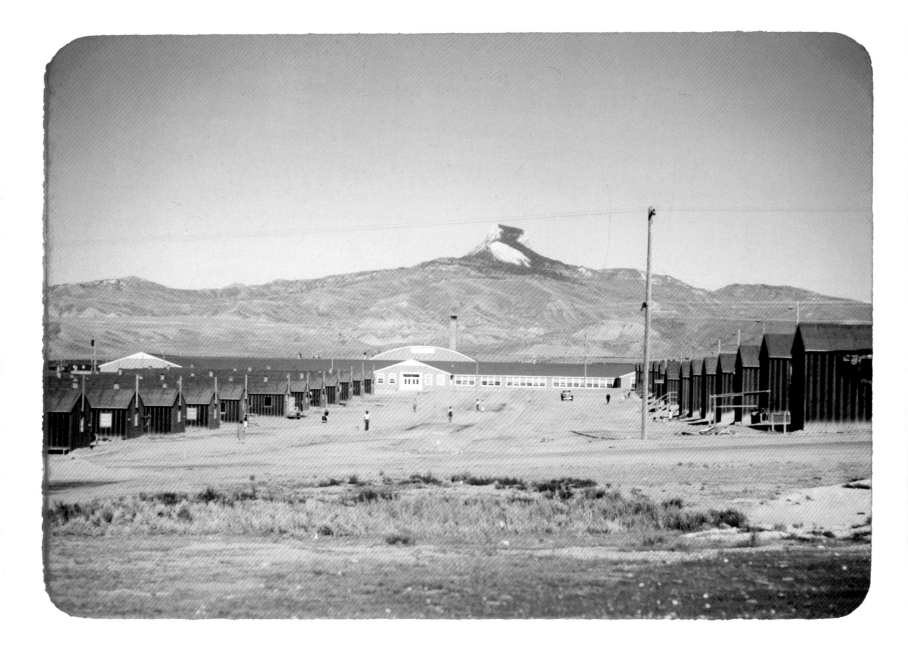

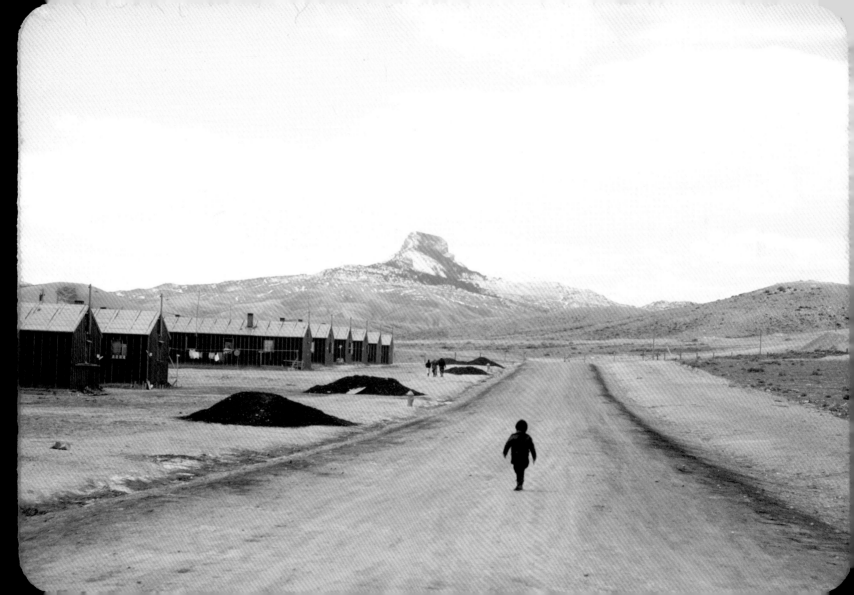

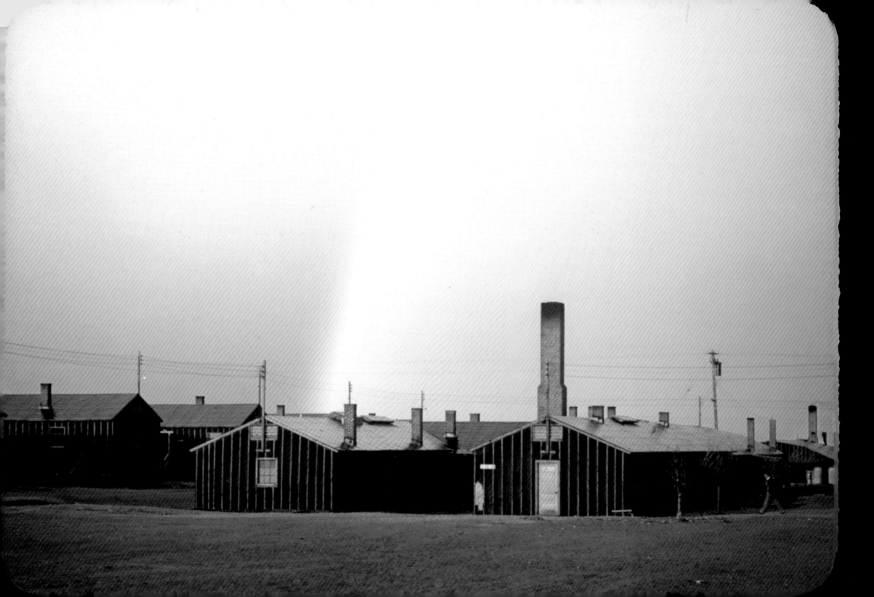

A group of children line up for a photo in front of a barrack wall. Billy Manbo is on the far right.

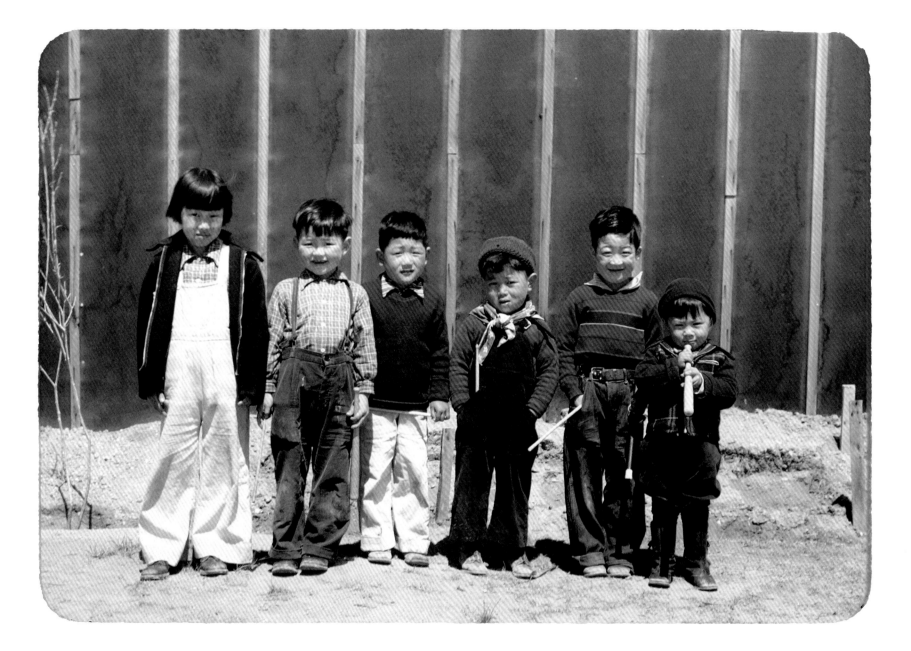

Bill Manbo (left) and a friend sit on Manbo's front steps, showing off their model racing cars. Manbo used scrap lumber and Celotex wallboard to build a small sheltered porch on the landing in front of his barrack door. On the outer wall to the left of the door, he wrote the family name, spelling it "Manbeaux" as if it were French.

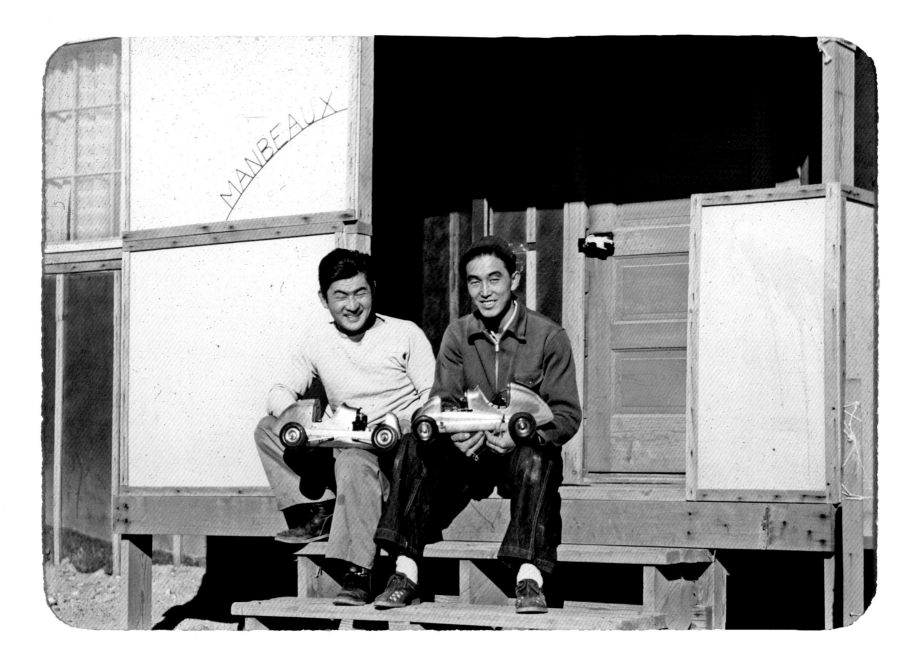

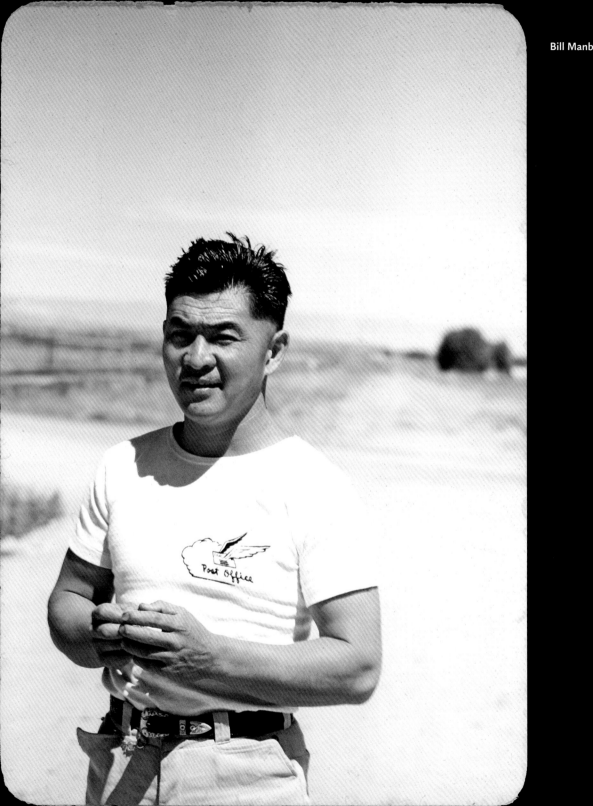

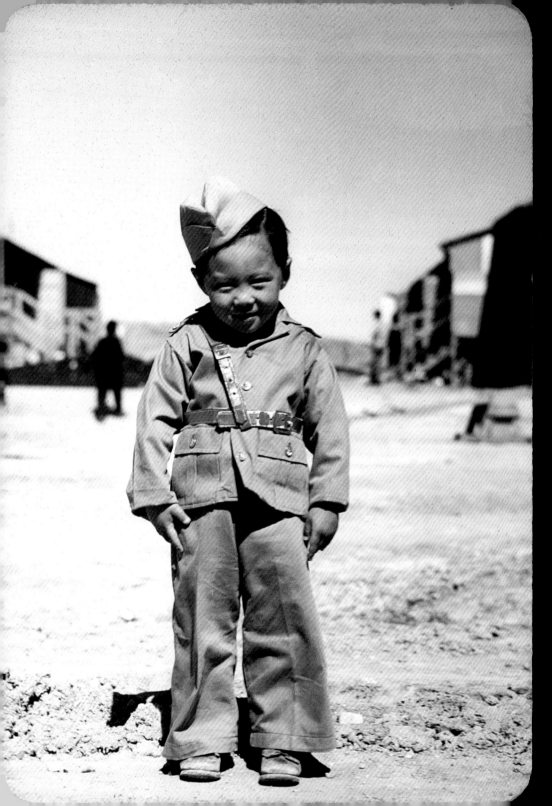

Billy Manbo.

Billy Manbo poses for a family photograph while holding a toy airplane. Behind him, *left to right*, are his mother Mary, his grandparents Junzo and Riyo Itaya, and his aunt Eunice Itaya.

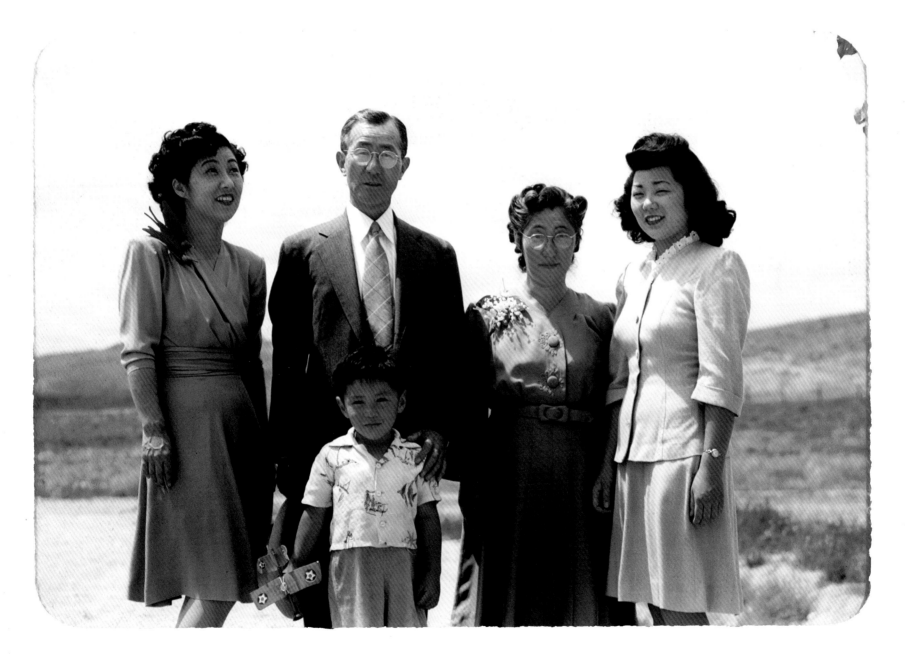

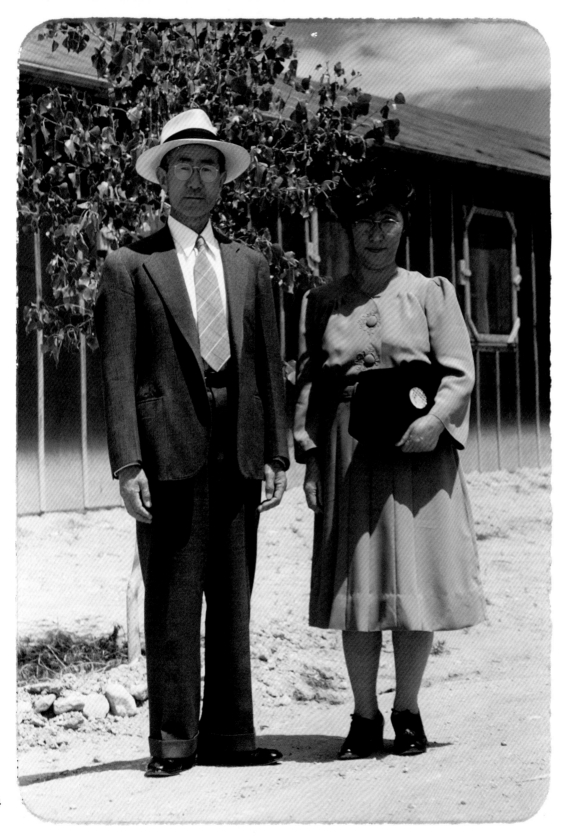

Junzo (left) and Riyo Itaya.

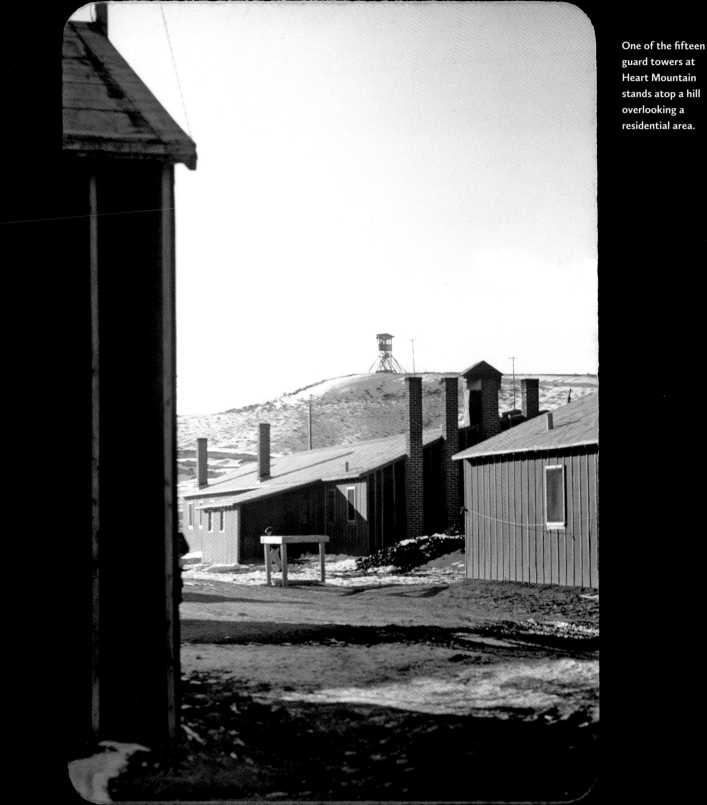

One of the fifteen guard towers at Heart Mountain stands atop a hill overlooking a residential area.

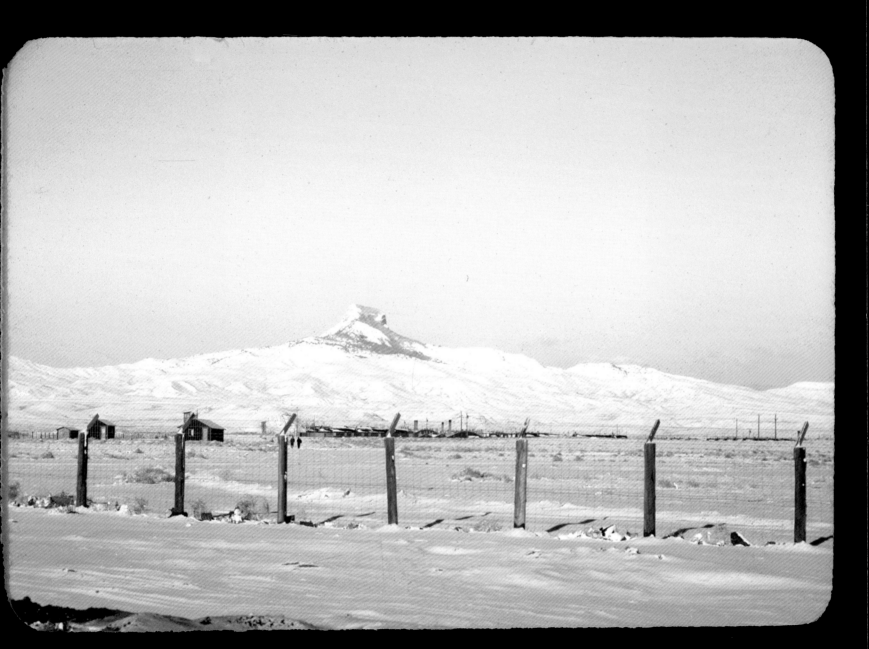

The icicles hanging from the eaves of the barracks emphasize the cold of a Wyoming winter.

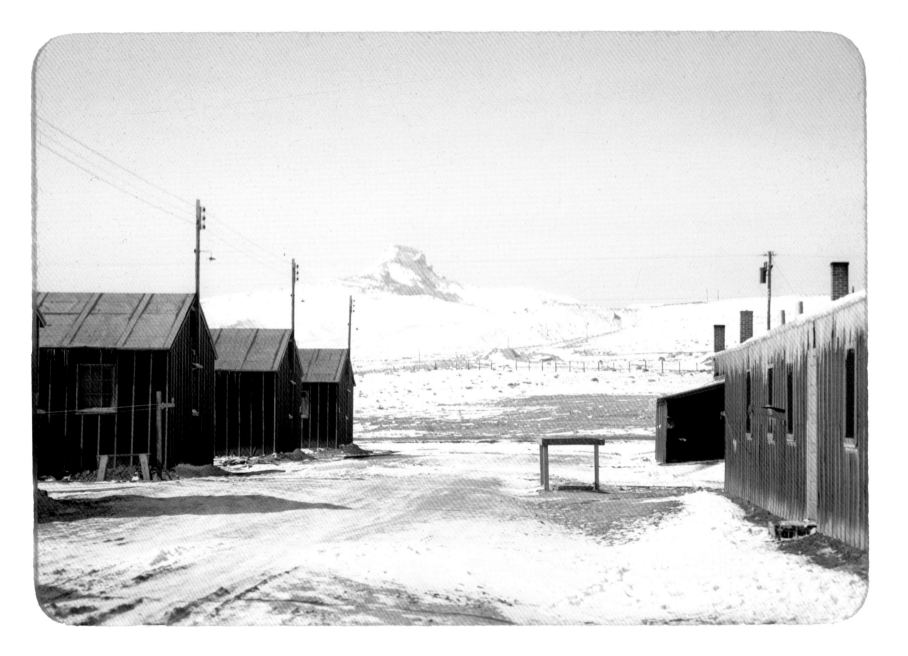

Dawn in the camp.

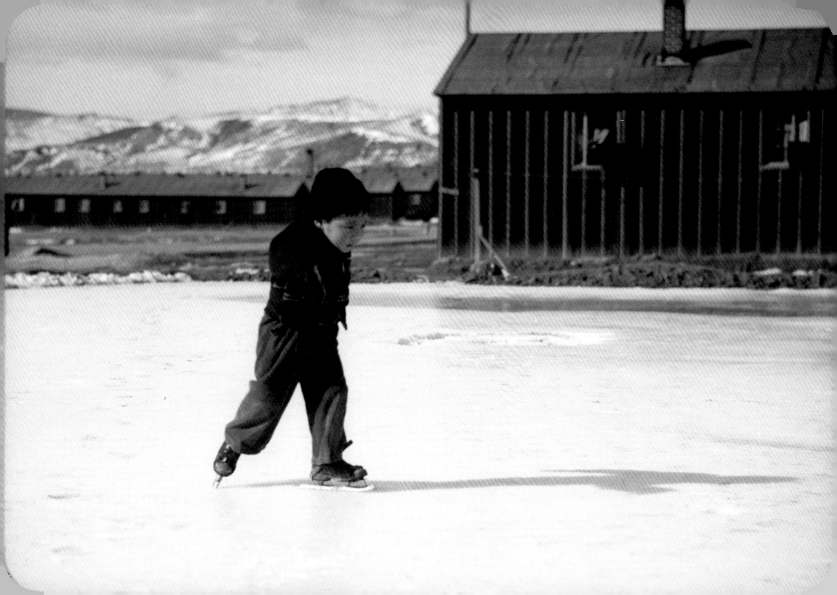

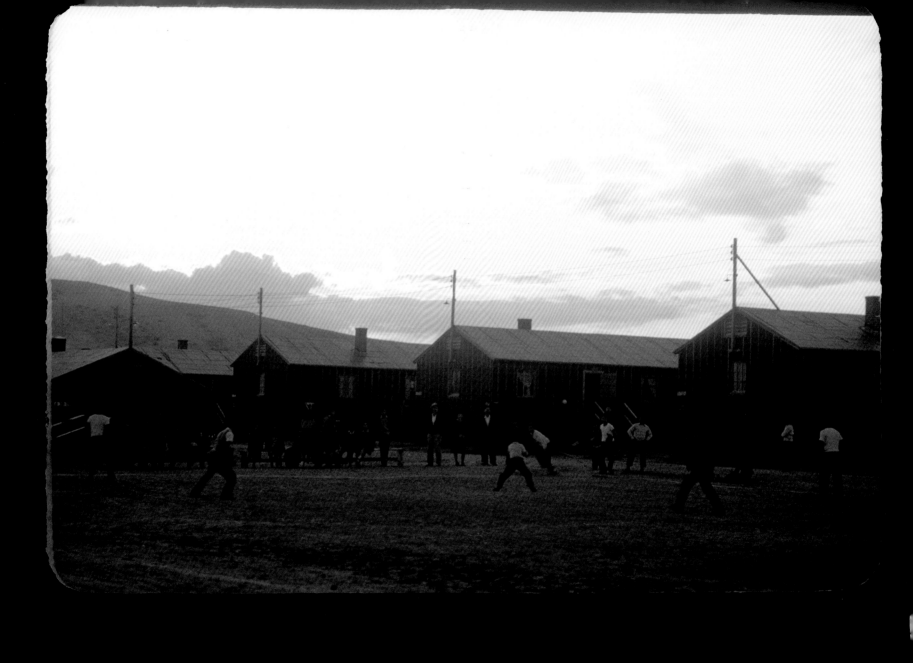

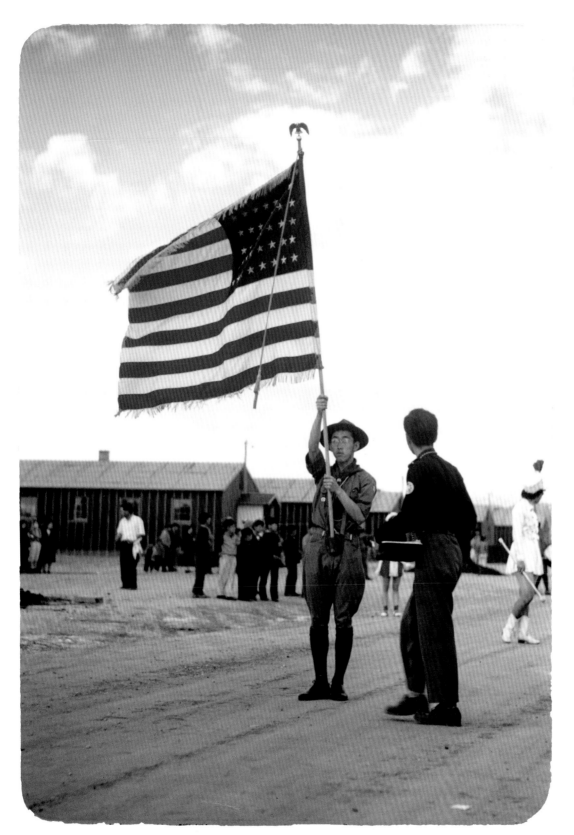

A Boy Scout, and behind
him a drum majorette,
at the head of a parade.

At a parade, all attention turns to the Boy Scout drum and bugle corps.

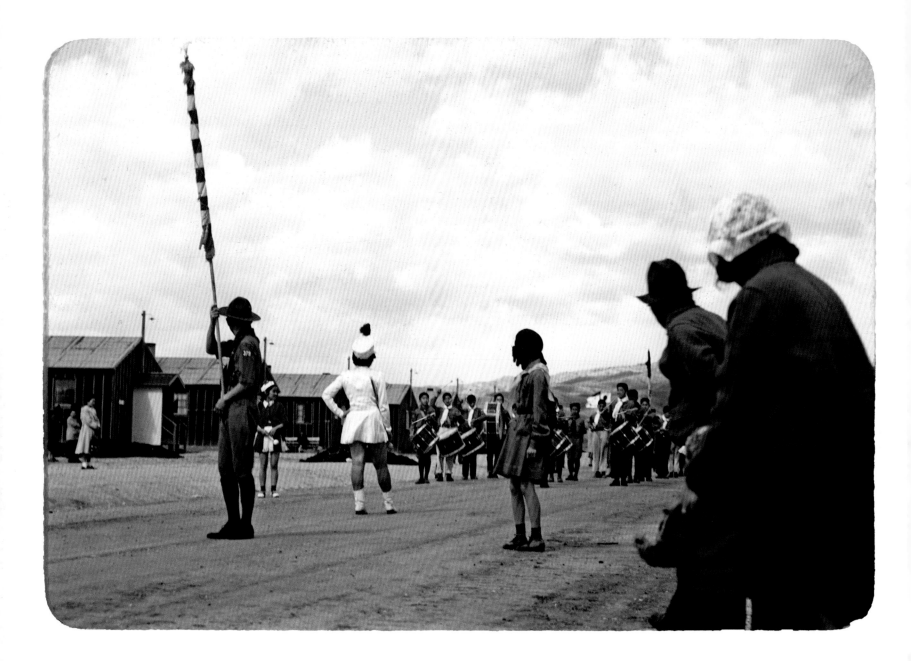

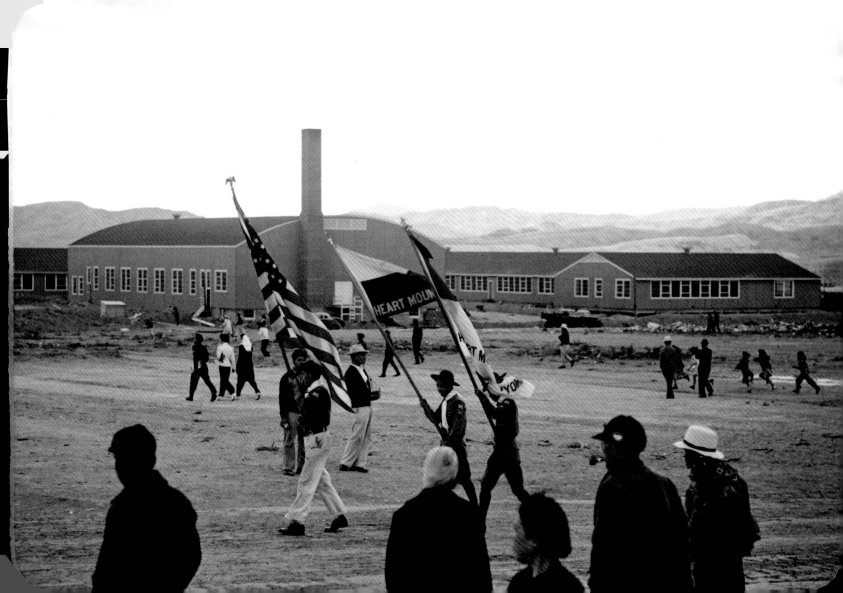

Young women chat at Bon Odori, a dance ritual performed during Obon, a summertime Buddhist festival commemorating one's ancestors. Bon Odori was held at Heart Mountain in July 1943 and July 1944; it is not known which of these two celebrations is pictured.

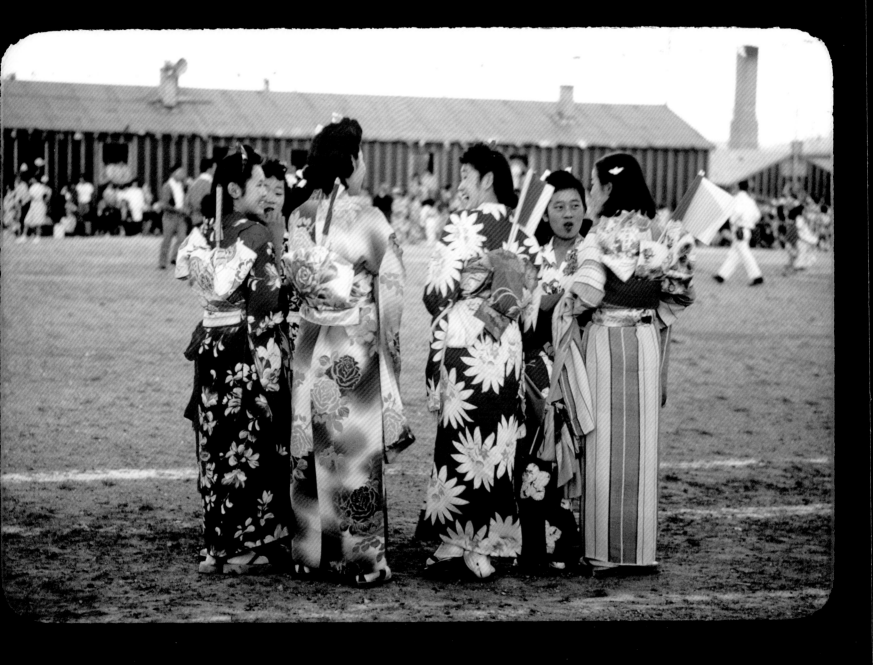

Bon Odori dancers.

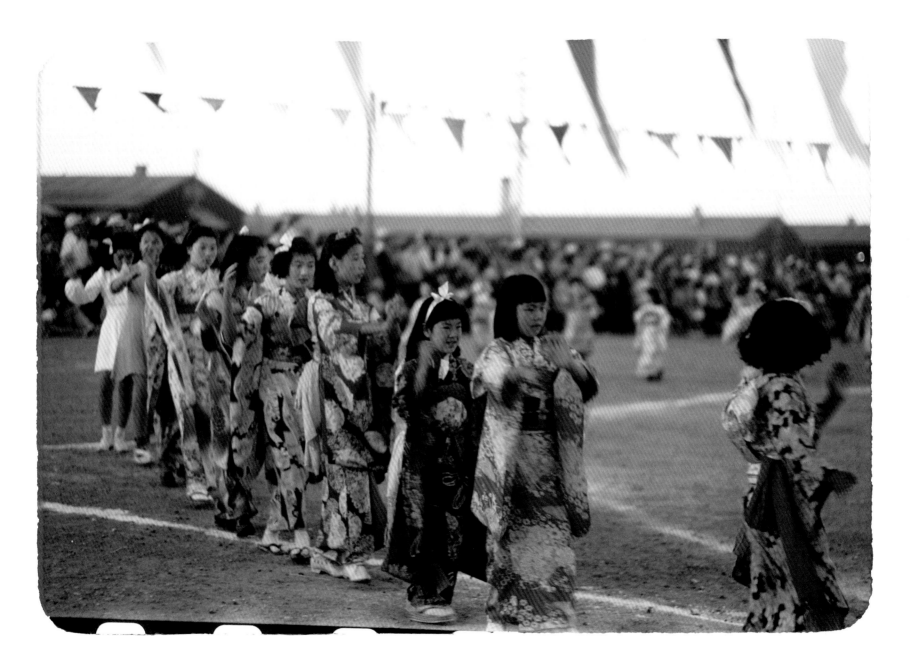

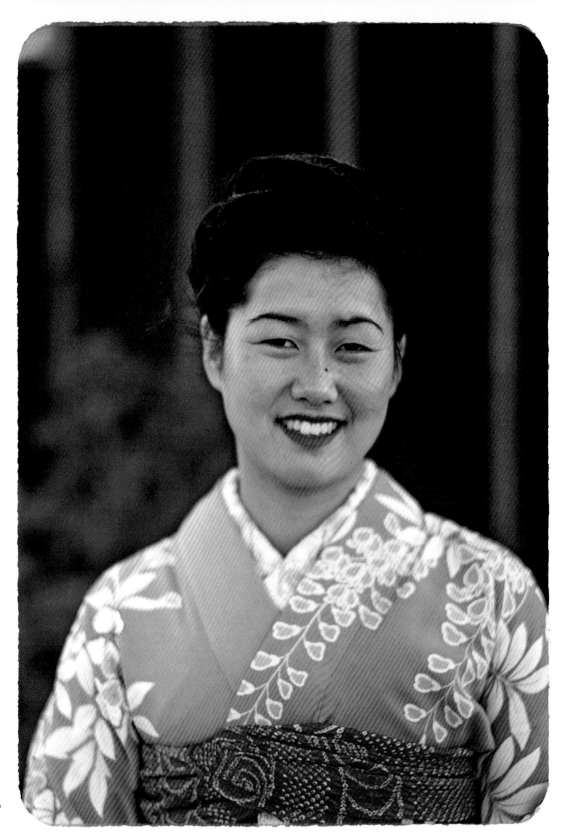

Close-up of a Bon Odori dancer.

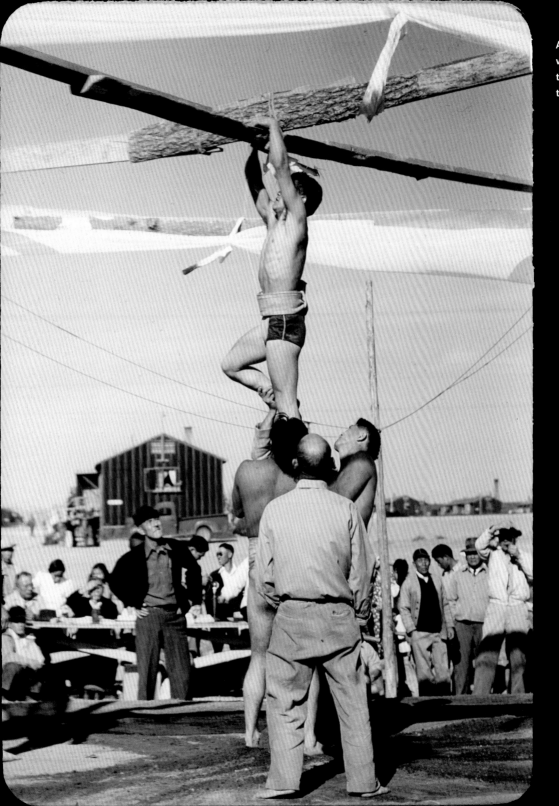

A sumo wrestler works on the temporary roof of the sumo ring.

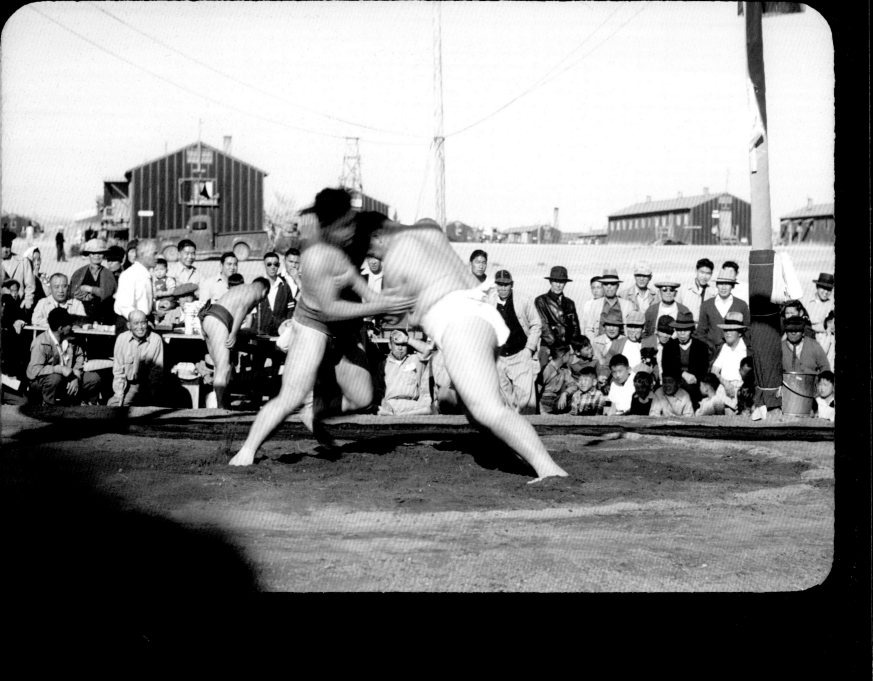

A light moment during a sumo match.

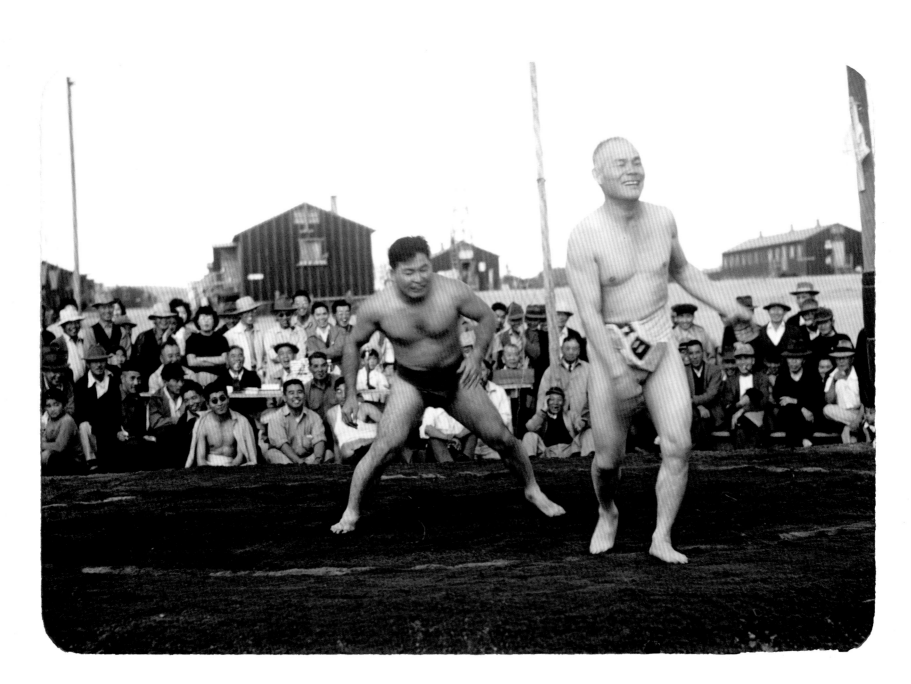

At Bon Odori, dancers circle around the *yagura*, a wooden scaffold made specifically for the summertime festival.

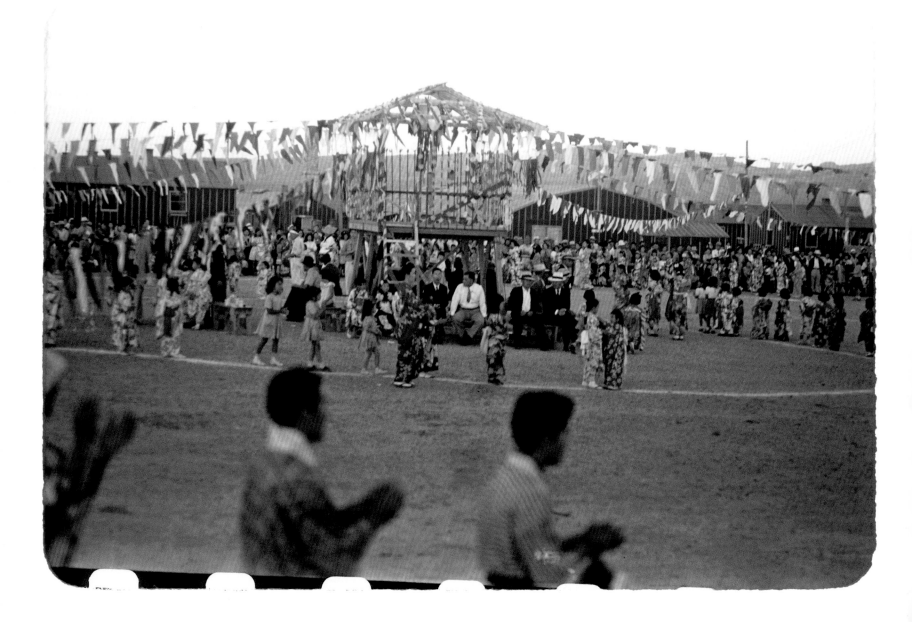

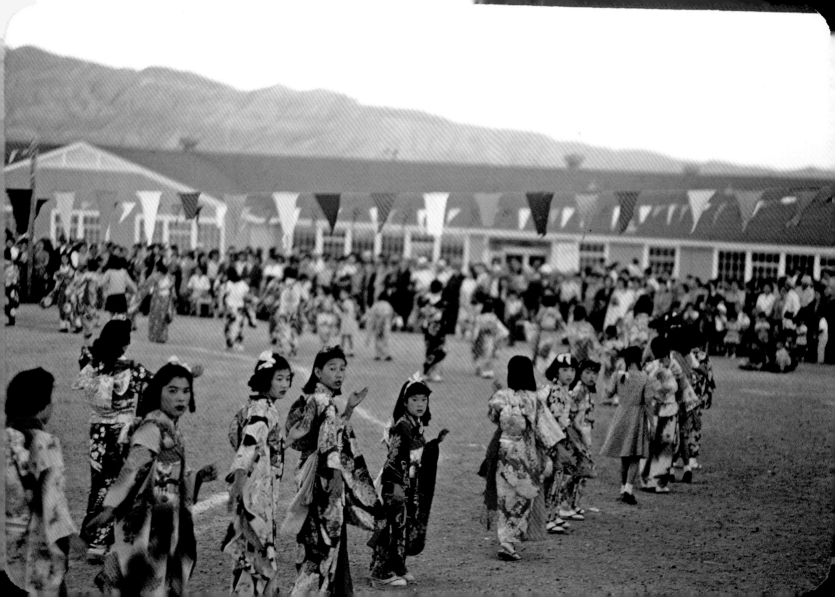

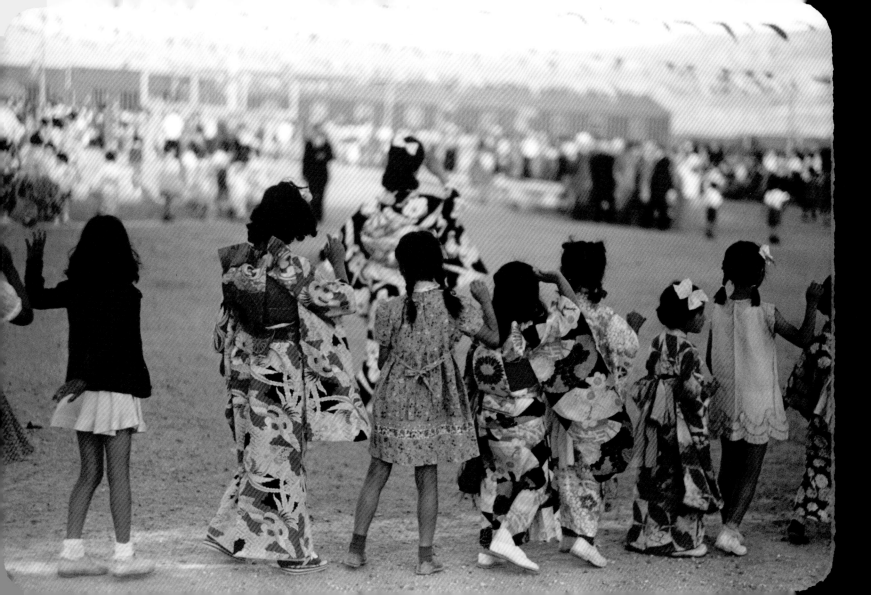

Lights coming on in the camp just after sunset.

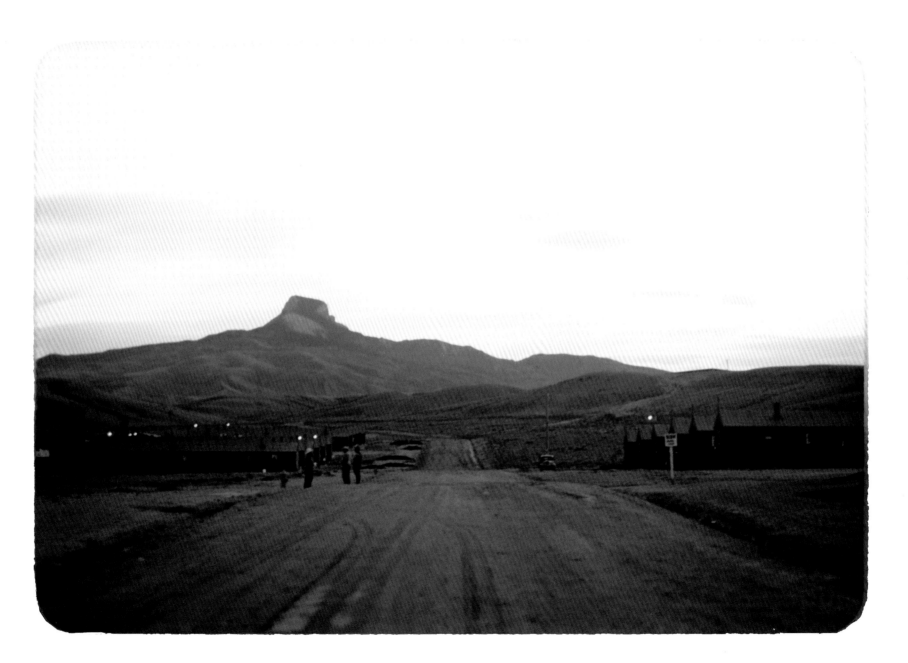

Dusk near the northwestern edge of the camp's residential area.

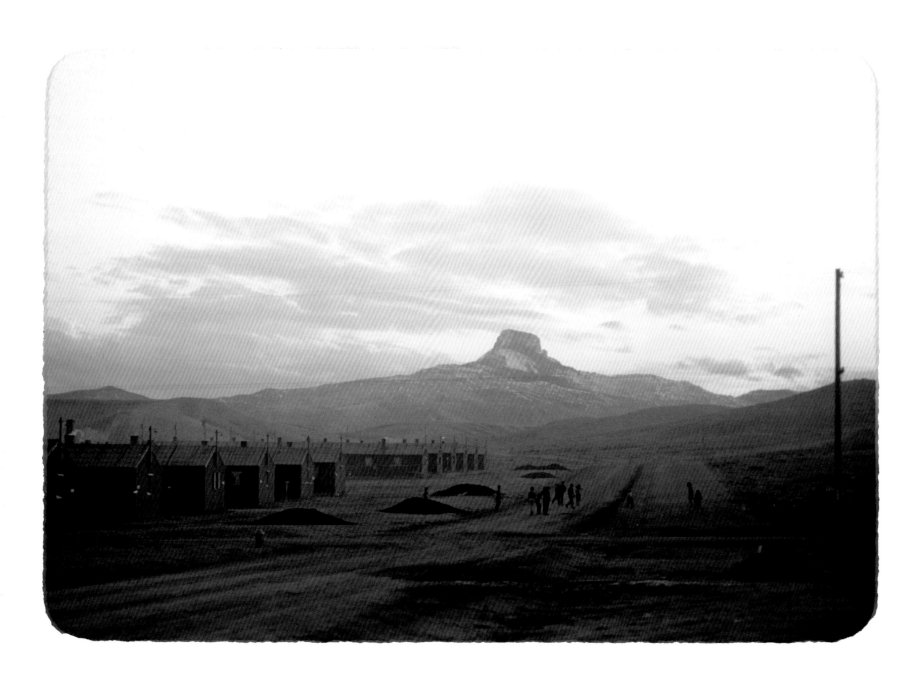

Bill Manbo poses with Billy at the Grand Canyon of the Yellowstone in Yellowstone National Park in September 1943.

Members of Heart Mountain's fire department work to put out a fire.

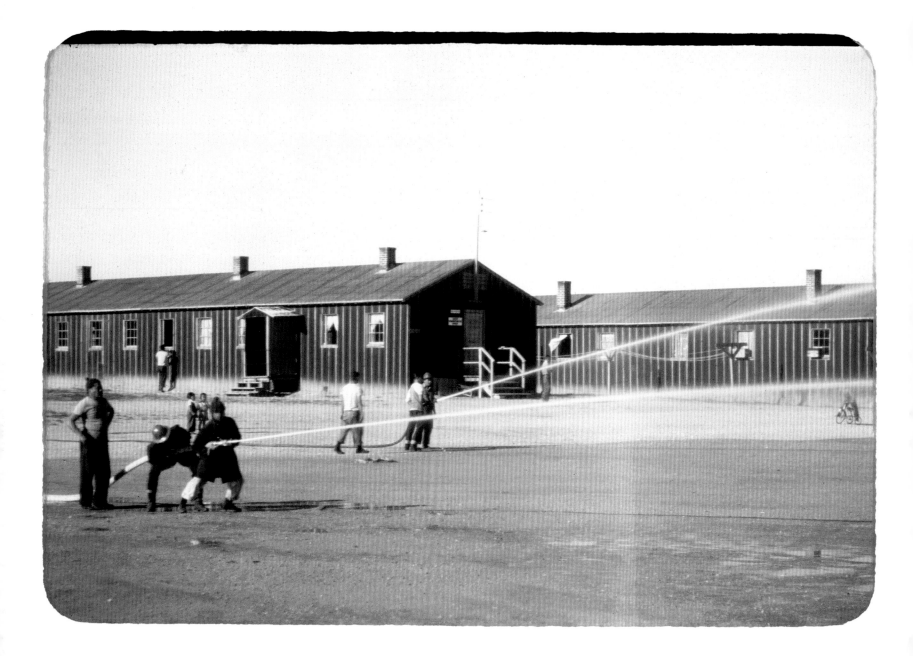

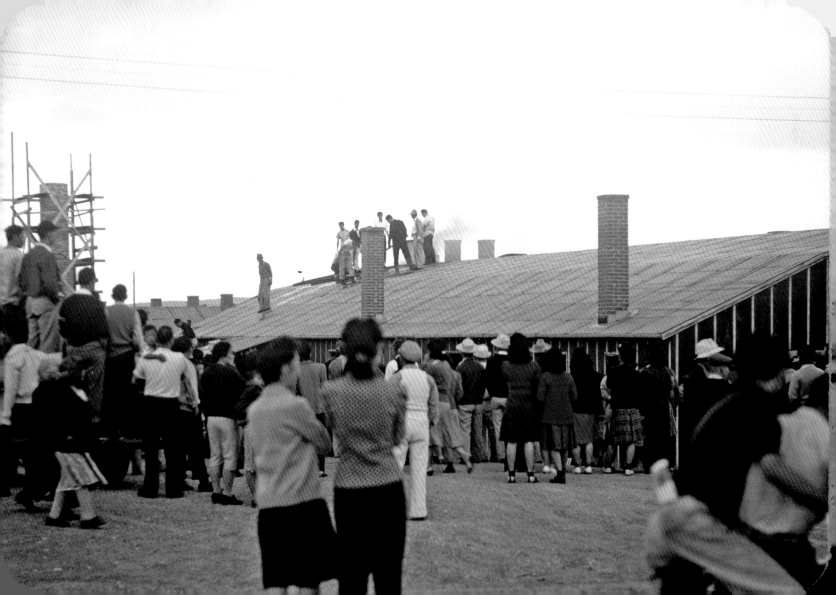

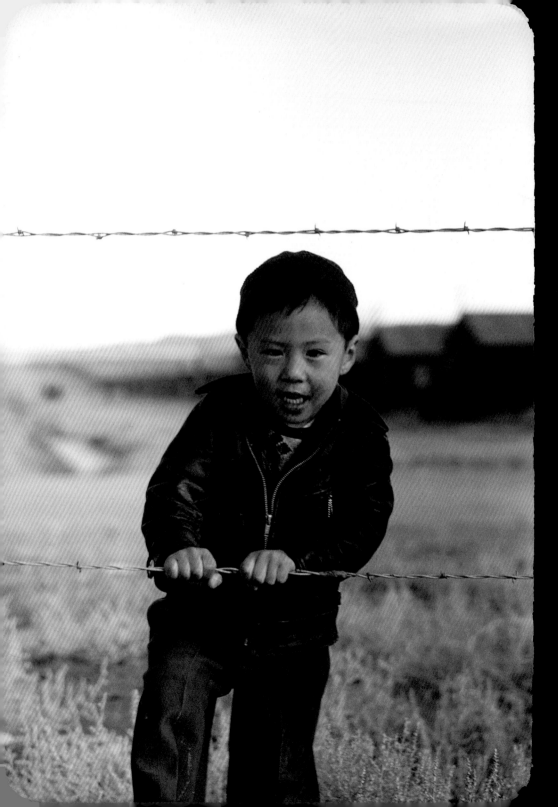

A portrait of Billy Manbo at a
barbed-wire fence.

Billy Manbo eats ice cream
in his pilot outfit.

Billy Manbo (left) with a friend.

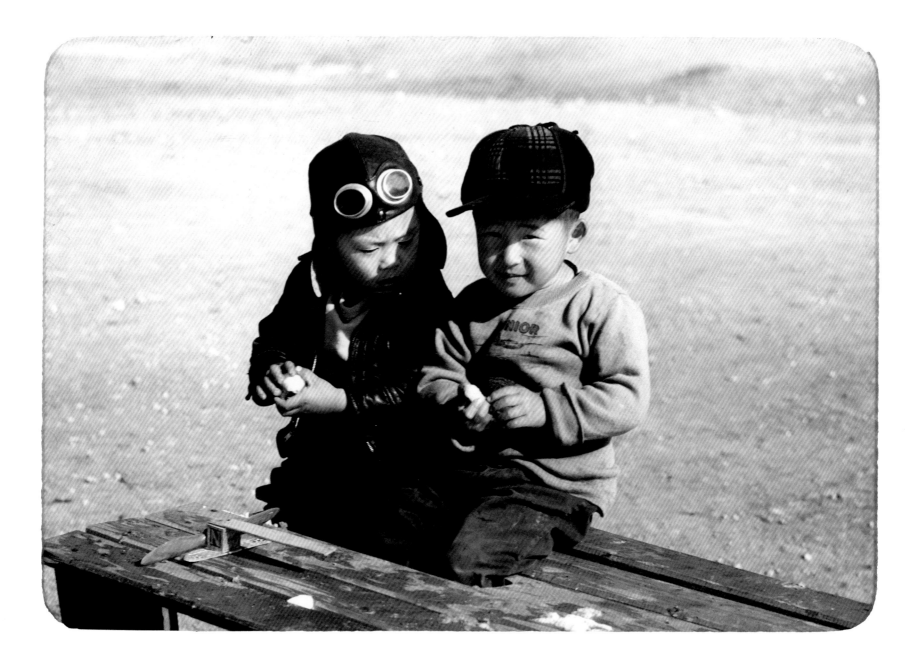

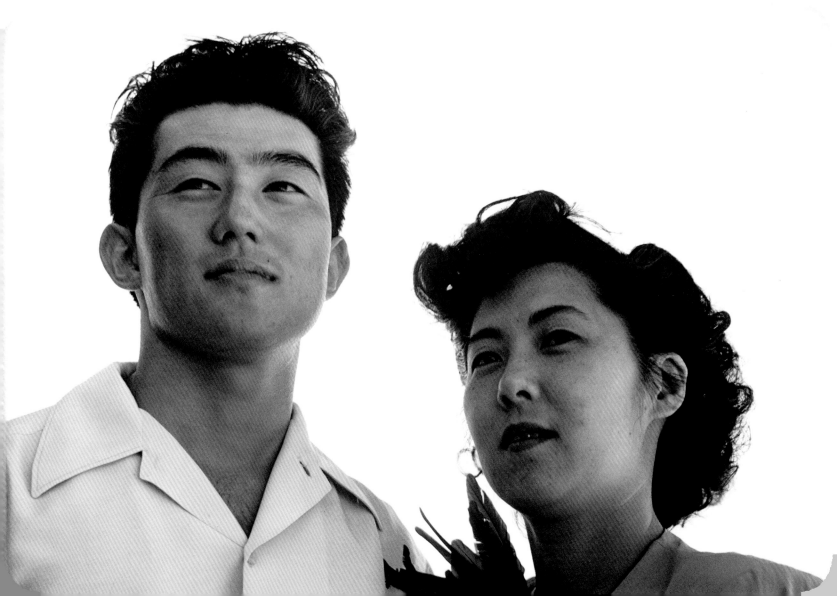

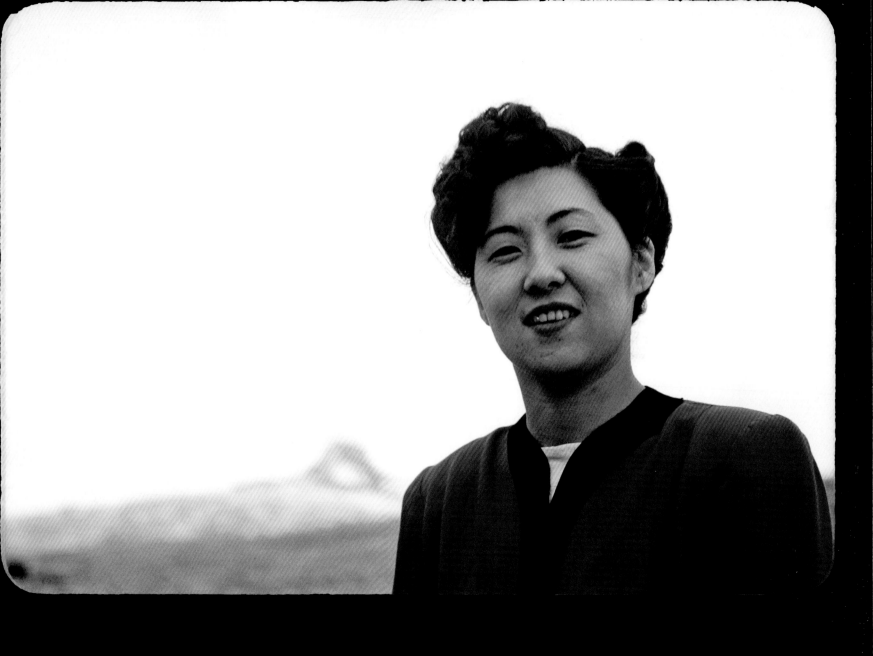

Billy Manbo, sporting suspenders, stands in front of his uncle, Sammy Itaya, in this group portrait. Also in the group are Junzo Itaya (far left), Riyo Itaya (holding an unidentified toddler), and Mary Manbo (second from right). The others in the photograph are unidentified.

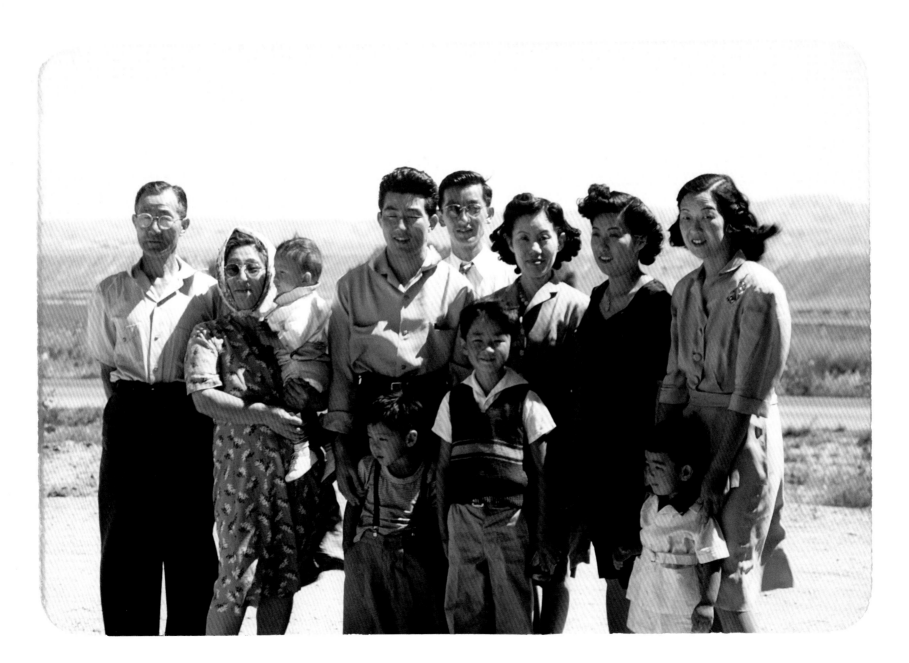

In the company of three unidentified friends, Mary Manbo points into the distance and Billy Manbo crouches on rocks.

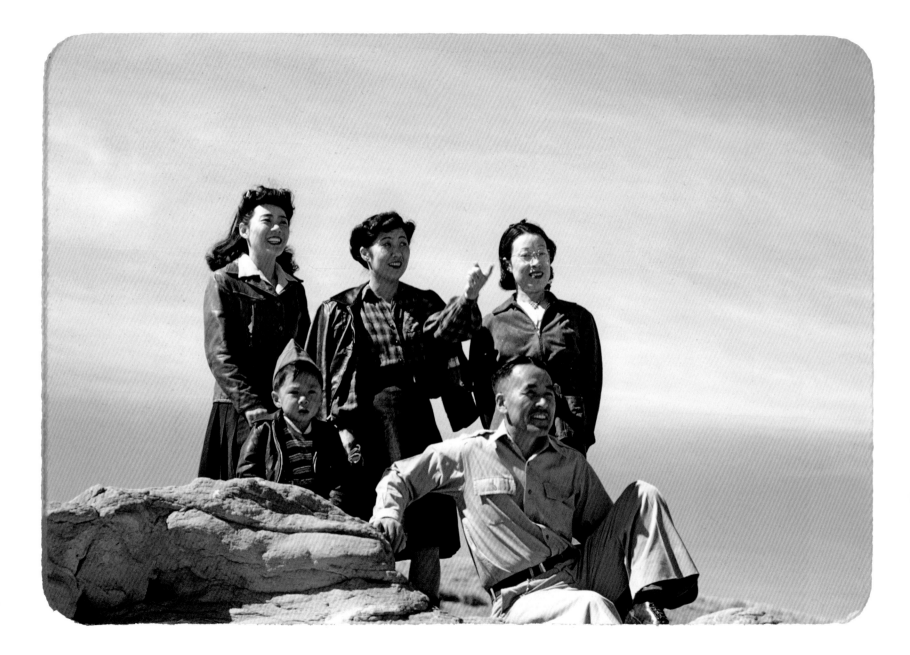

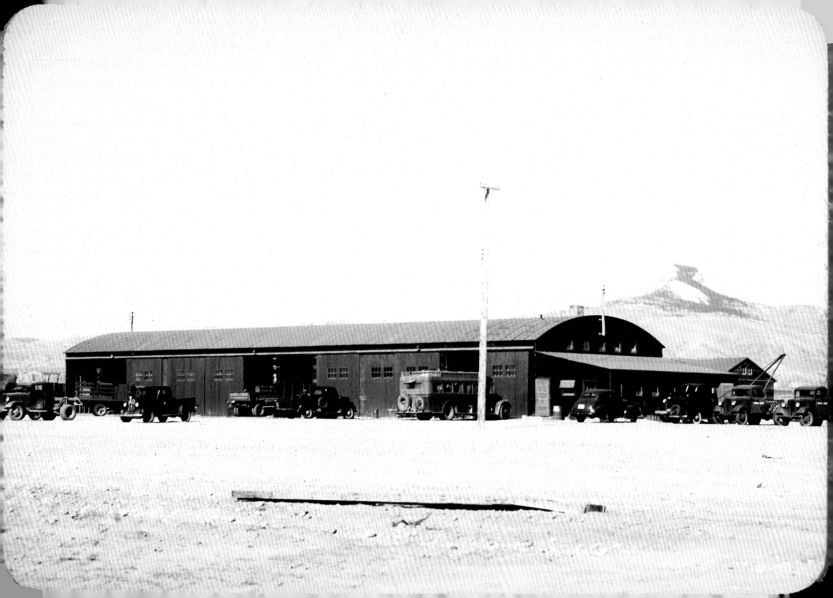

Three men walk along the top of an irrigation pipe, with the top of Heart Mountain in the background. Slung over the third man's shoulder is the homemade tripod that Bill Manbo made from scrap lumber and hardware taken from a camp latrine.

At dawn, a light burns in a single barrack room's window.

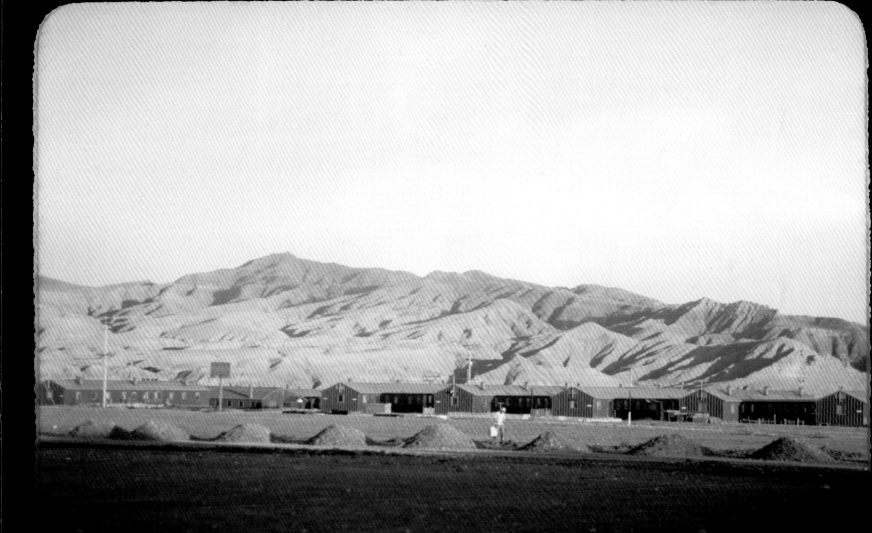

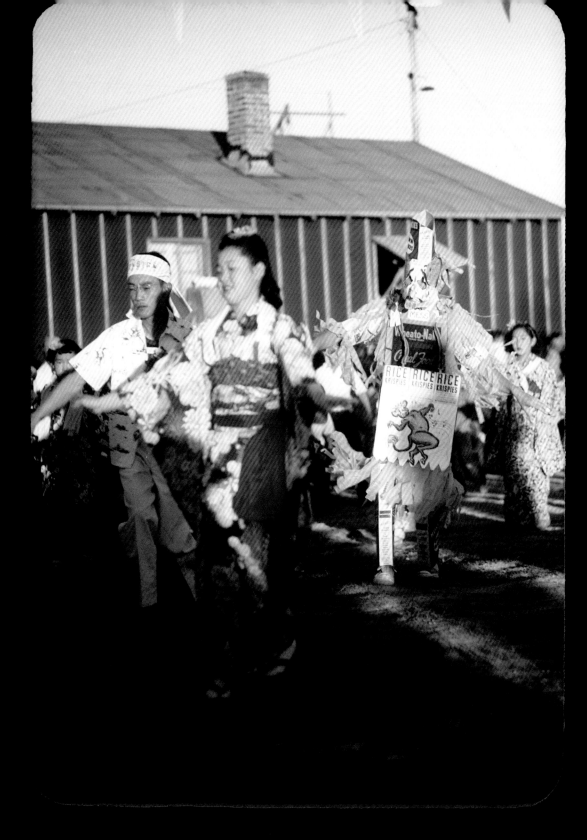

This kachina-like Bon Odori dancer made a costume out of breakfast cereal boxes, including Rice Krispies and Wheato-Naks.

Camera in Camp

Bill Manbo's Vernacular Scenes of Heart Mountain

JASMINE ALINDER

Arms are spread like wings with fingertips outstretched and palms facing down. The dancers keep time as they move in a circle, one foot forward, while their eyes gaze at the ground. In this Bill Manbo photograph of Bon Odori at the Heart Mountain Relocation Center, the colors of the dancers' costumes are vibrant and alive. One woman wears a beautiful kimono belted in bright red. A man to her left is decked out in empty food containers accented with chaotic paper ruffles and front plates of cardboard armor fashioned from Rice Krispies boxes. Their joyous motion contrasts sharply with the drab barrack backdrop, where thin lines of wood run vertically breaking up the tarpaper into repeating black bands. Regularity, sparseness, and imprisonment may mark the setting, but celebration, color, and life mark the participants. Families who had been identified by numbers, whose Americanness and citizenship were trumped by ancestry, rejoice here as they dance in a ceremony of ancestral remembrance.

This photograph raises interesting questions both about the use of the camera in Heart Mountain and about the celebration of Japanese cultural practices like Bon Odori inside the concentration camp. During the World War II imprisonment of Japanese Americans, photography became a representational battleground.[1] Initially, the camera was a target and tool of repression. The government and military classified the camera as a weapon of war, in the same category as guns, bombs, and ammunition. In the days following Pearl Harbor, the FBI conducted searches and arrests, and some Japanese Americans destroyed objects and artifacts that might have tied them culturally to Japan, including photographs. Manbo's father-in-law, who had ties to a Japanese-language school, was detained by the FBI after the bombing of Pearl Harbor and did not rejoin the family until they were in camp.[2] As they prepared for the mass incarceration, Japanese Americans were compelled to turn over their cameras along with other contraband.

In March 1942, the newly formed civilian agency called the War Relocation Authority (WRA) gradually began to take over management of the camps from military control. Full of New Deal administrators, the WRA hired photographers to depict Japanese Americans not as the enemy but as loyal and cooperative subjects.[3] Although WRA photographers produced thousands of images (mostly black

Snapshots are part of the material with which we make sense of our wider world. They . . . are part of our personal and collective past, part of the detailed and concrete existence with which we gain some control over our surroundings and negotiate with the particularity of our circumstances.

—Patricia Holland, "History, Memory and the Family Album," in Jo Spence and Patricia Holland, eds., Family Snaps: The Meaning of Domestic Photography *(1991)*

and white), vernacular, everyday images of life made by the incarcerated are rare because inmates were forbidden from bringing cameras with them into the concentration camps. Occasional snapshots and some home movies exist, and once Japanese American soldiers returned to their families behind barbed wire while on furlough, they often brought cameras with them. Manzanar, in southern California, had a photography studio, and most of the camps produced newspapers and school yearbooks that were photographically illustrated. But I do not know of another cache of color images of the size created by Bill Manbo.

Why did Heart Mountain administrators allow camp life to be photographed by an imprisoned Japanese American? Documents located in the National Archives reveal that instead of a blanket prohibition, WRA officials debated the contraband status of the camera.[4] Some believed that incarcerated citizens should have access to cameras, as long as they were imprisoned outside of the Western Defense Command. In a letter dated October 26, 1942, to WRA director Dillon Myer, WRA regional director Joseph Smart writes:

You will notice that in our proposed regional instruction no mention was made of cameras as contraband. This question has been the subject of considerable discussion with the Project Directors, and we all feel that the possession and use of cameras should be permitted on the projects. We would prefer that evacuees on leave not use cameras because of possible difficulties with outside people and peace officers, but I doubt if we have any right to prohibit it. This matter was discussed with Mr. John Baker in Denver the other day and I believe he proposes to recommend that evacuees not be permitted to take pictures in the projects. Our project directors and I earnestly hope that his view in this matter will not prevail.[5]

Smart then listed several reasons why Japanese Americans should be allowed access to cameras inside the camps. In addition to dismissing the fear that Japanese Americans would use cameras to photograph "military objectives," Smart reasoned that Japanese Americans should have the right to create a photographic record of their lives, "particularly to record the lives of their youngsters in an informal fashion." Smart is arguing here for the right to the family snapshot.

Discussions of photography and rights most often focus on images that contain documentary evidence of crimes, death, or torture. But during the incarceration of Japanese Americans, two-thirds of whom were U.S. citizens by birth, the denial of the camera was part of the eclipsing of a wide range of rights, some constitutional (imprisonment without due process) and others that were part of a more informal array of rights that included the right to representation (cameras as contraband). The argument to restore the right to photography was not embedded in a desire to document the suffering that the imprisonment caused but rather in the desire to document daily events in spite of the imprisonment, and through the vernacular photograph to reclaim a piece of the rights of citizenship. As Ariella Azoulay argues in *The Civil Contract of Photography*, "Becoming a citizenry of

photography entails seeking, by means of photography, to rehabilitate one's citizenship or that of someone else who has been stripped of it."[6] The very ordinariness of the practice of photographing birthday parties and sporting events signifies how essential those kinds of everyday snapshots are for constructing a normal sense of self.

Smart also reasoned that with the abundance of spare time facing prisoners, the camera could give Japanese Americans a constructive way to spend their days. Bill Manbo seems to have been just the kind of person that Smart had in mind. Manbo was an amateur photographer, a hobbyist, and his experience in Heart Mountain became framed through his camera's lens. Manbo clearly took advantage of the allowance of the camera to focus on the growth of his own son and events inside camp, as well as to train his own eye in photographic composition. In terms of vernacular photography, Manbo's lens often gravitated toward common subjects—a rainbow, a beautiful sunset, a family portrait, a celebration. Yet in these photographs, it is impossible not to notice the barracks, the barbed wire, the guard towers, and therefore how measured the joy, the play, and the beauty must have been.

The news of the release of some articles from contraband status made its way to Japanese Americans in camp newspapers.[7] During the spring, summer, and fall of 1943, newspapers in camps located outside of the Western Defense Command ran front-page articles with headlines such as "Defense Command Releases Contraband," and "Contraband Ruling Eased."[8] The conditions for the release of cameras and other items included that objects could only be returned to original owners and that those owners had to be either U.S. soldiers, citizens living outside of the Western Defense Command (WDC), or someone exempted from WDC proclamations. But retrieving these objects, which were stored in California warehouses, was not easy and entailed requesting the items through forms and providing birth certificates to prove identity and citizenship, as well as the receipt for the item. While cameras remained contraband for Issei, the *Denson (Arizona) Tribune* reported that they would be allowed to request their "long-wave" radios.[9]

The *Heart Mountain Sentinel* stated on page 8 of its April 3, 1943, issue that "applications for cameras [were being] accepted." Apparently, the new contraband policy had been reported prior to April 3, but the evacuee property office had run out of contraband request forms. It would be hard to imagine that the relaxation of contraband rules was not very welcome and important news for Bill Manbo. In fact, enough Japanese Americans in Heart Mountain retrieved their cameras from storage to form a camera club. A photograph from the Anaheim Public Library depicts ten men and three boys (eleven men if you count the photographer), many of whom hold their cameras or have them hanging from straps around their necks.[10] The photographers positioned themselves outside of the camp boundaries marked by barbed wire but made sure to have Heart Mountain itself visible prominently in the background. According to his son, Bill Manbo is the club member in the photograph who stands on the far left.[11]

Before Nisei like Manbo and the rest of the Heart Mountain Camera Club were given access to their cameras, camps, including Heart Mountain,

The Heart Mountain Camera Club in the spring of 1944. Bill Manbo appears at the far left.
Courtesy of the Hirahara Family Collection, Anaheim Public Library.

had served as photographic backdrops for profes-
sional photojournalists. In January 1943, two well-
known *LIFE* magazine photographers had spent a
week at Heart Mountain. According to the *Sentinel*,
Hansel Mieth and Otto Hagel were on assignment
as a follow-up to a visit made in September 1942
by a different *LIFE* photographer. During the same
month that Hagel and Mieth photographed Heart
Mountain, Tom Parker also set up his camera in
the camp on assignment for the War Relocation
Authority. Parker took his camera all over Heart
Mountain and made several photographs of Bill
Hosokawa, the editor of the *Heart Mountain Sen-
tinel*. Parker, who had photographed Heart Moun-
tain at least once earlier in the fall of 1942, posed
Hosokawa with his wife and child as the model
Nisei family.

A second WRA photographer poised his camera
on Heart Mountain in the fall of 1943. Hikaru Carl
Iwasaki was the only Japanese American photogra-
pher employed full-time by the WRA. Initially hired
out of Heart Mountain as a darkroom technician,
Iwasaki was promoted to photographer, a position
he continued to hold until 1946.[12] One Iwasaki pho-
tograph depicts Heart Mountain youth at a dance.
Instead of Bon Odori, the paired couples and attire
suggest an American-style high school dance. The
caption for the photograph reads, "Dancing is one
of the chief forms of recreation at the Heart Moun-
tain Relocation Center. This scene, in the high
school gymnasium, shows the portion of the crowd
at a school dance to which the public was invited."
As a photographer for the WRA, Iwasaki traveled
to other camps and to towns outside of the WDC
where Japanese Americans were resettling. The vast

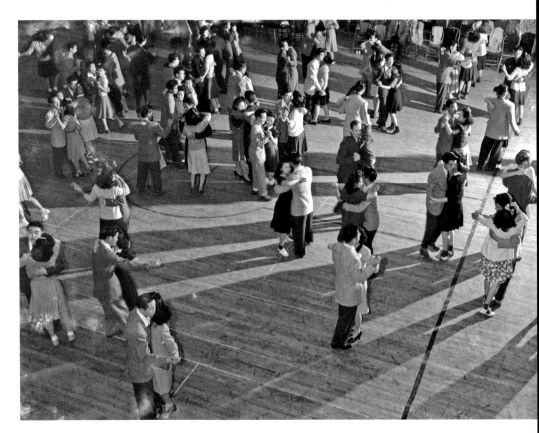

Photograph by WRA photographer Hikaru Carl Iwasaki of a dance at the Heart
Mountain high school gymnasium in the fall of 1943. Courtesy of the National Archives,
photo no. 210-G-G200.

majority of these photographs resemble other WRA photographs in their relentless focus on optimistic Nisei engaged in work and play. Although searches did not result in any Iwasaki images of Bon Odori, he did create some lovely still lifes of Japanese cultural objects created in camp, including an intricate woodcarving and homemade *geta* (sandals).[13]

Another WRA photographer, however, did make images of a Bon dance at Amache in Colorado. Several photographs by Joe McClelland of the August 1943 festival are included in the National Archives digital collection. Captions are brief and relate that more than 1,000 Japanese Americans participated in the festival sponsored by the Granada Buddhist Church.[14] The black-and-white images themselves are distant and stiff. They have none of the sense of movement and joy that Manbo's photographs possess. Comparing them demonstrates some of the differences between typical documentary images and vernacular snapshots. The WRA photographs are black and white, the photographer is removed from the action, and the subjects do not seem to perform for the lens but in spite of it. Manbo is much closer to the dancers. The frame of his camera is tilted, which gives the image a sense of movement and informality. In the photograph on page 82, the central woman in the kimono does not look into the camera's lens, but her warm smile radiates through it. It is difficult to imagine that she is unaware of Manbo's camera given that he is just a few paces away, and judging by her expression, she accepts the close proximity.

Another typical difference between the two photographic genres is captioning. The War Relocation Authority took captions very seriously. The Photographic Section existed under the umbrella of the Information Division, and WRA photographers directed their images to a central office in Denver where clerk-stenographers used notes from the photographers to produce captions that would "conform to the journalistic standards of brevity, narrative value and attractiveness."[15] But WRA captions performed much more work than these brief directions suggest. Captions directed photographic meaning in ways that emphasized the government and military's benign treatment of Japanese Americans, along with prisoner complicity. Even in the McClelland photograph of the Bon dance, the caption notes that the Japanese ritual took place on American ritual space: the camp's baseball diamond. The text that accompanied WRA photographs was a key site of meaning that at times overrode the content of the photographs themselves.[16]

Bill Manbo's photographs, by contrast, have no captions. In their original format, they exist as slides. While snapshots may have informal captions, often scribbled on their versos, or may be placed in albums that suggest a narrative relationship, slides do not lend themselves to any type of written caption. Rather "captions" are provided during the performance of the slide show, both orally and in their sequencing. Manbo's son remembers his father showing the slides to friends, but by the mid-1950s he does not recall his parents talking about their wartime experiences again.[17] In the absence of Manbo's narration, the photographer's explicit intentions are difficult to apprehend with certainty. But visual culture is often produced without directions from the producer. Even in cases where an artist records intentions, images

Photograph by WRA photographer Joe McClelland in August 1943. The WRA's caption for this photograph reads: "Granada Relocation Center, Amache, Colorado. Part of the approximately 1,000 dancers who participated in the Bon Odori festival sponsored by the Granada Buddhist Church on August 14. Spectators are shown in the background. This dance was held at night on the baseball diamond." Courtesy of the National Archives, photo no. 210-G-E621.

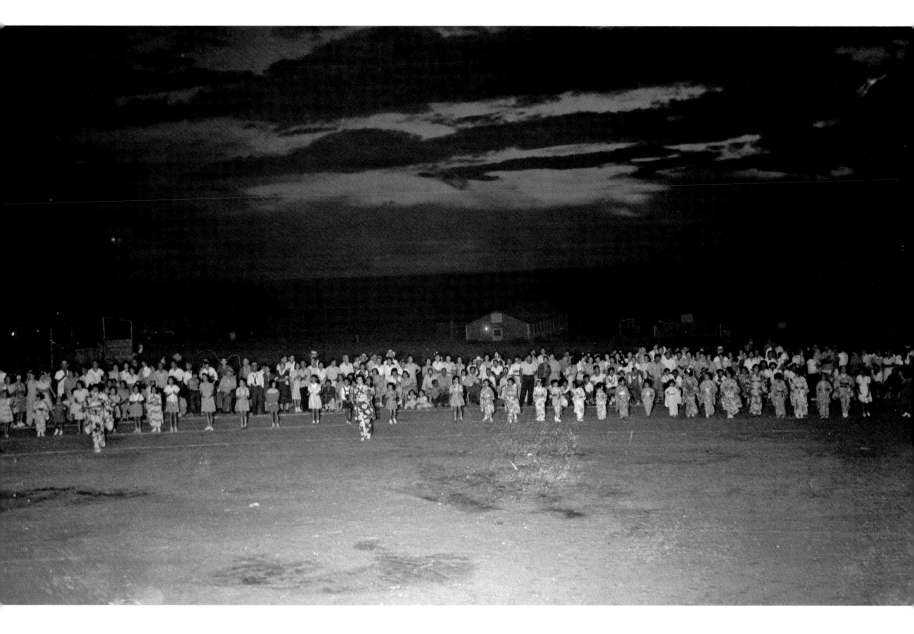

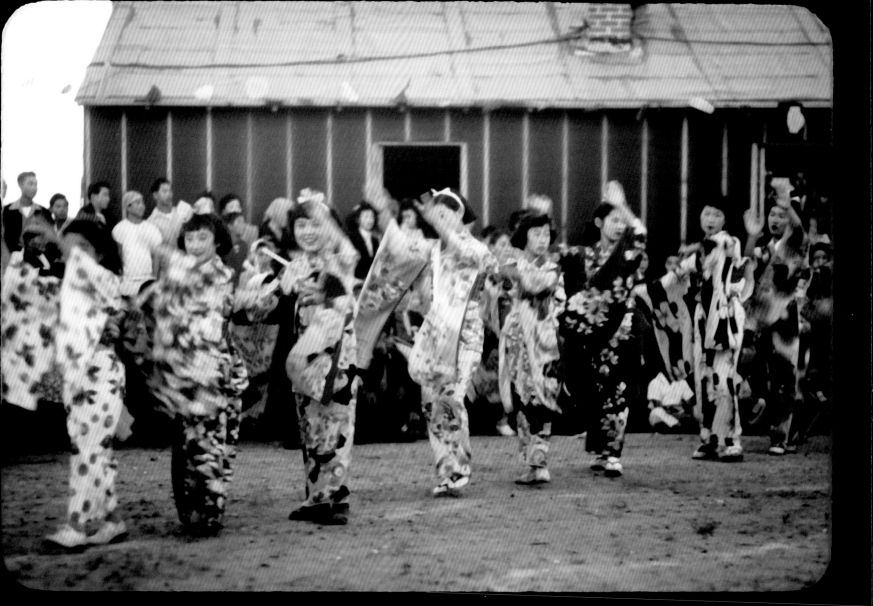

have multiple lives, and the author is never the sole dictator of meaning. Manbo may not have left diaries or notes explaining his photographs, but that does not mean that his photographs are unknowable. By adhering to the familiar visual rhetoric of vernacular photographs, Manbo in a sense has "captioned" his images. Repeating conventions of pose, subject, and composition places viewers on legible photographic ground. Reading Manbo's images against other photographs of the incarceration and with documentation from archival sources provides a fuller context for their interpretation.

The juxtaposition of these different types of dance photographs, made by WRA photographers and Manbo, also points to the tensions present in cultural acts for Japanese Americans at that time. The very nexus of Nisei identity—Americans by birth, Japanese by ancestry—was thought to be mutually exclusive by many who supported the mass incarceration. This belief was articulated by a *Los Angeles Times* editorial that reported: "A viper is nonetheless a viper wherever the egg is hatched—so a Japanese American born of Japanese parents, grows up to be Japanese not an American."[18] Similarly, one of the chief military proponents of incarceration argued that Japanese operated as a "national group almost wholly unassimilated and which has preserved in large measure to itself its customs and traditions."[19] A *Christian Science Monitor* reporter asserted that Japanese Americans are "member(s) of a race whose loyalties to the US have not been fully established."[20] The categories of American and Japanese were then aligned with the categories of loyal and disloyal. As one Japanese American wrote in frustration, "I'm an American, but I've got a Japanese face—what am I going to do?"[21]

In Manbo's dance photographs we see a range of activity that viewers may have identified as having either Japanese or American cultural connotations but unlikely both at the same time. Photographs that articulate the explicit mixing of Japanese and American cultural codes are rare. A WRA photograph by Tom Parker, for example, depicts a Japanese American man in his Heart Mountain barrack. The caption writer assigned to the image felt compelled to provide an explanation for the room's Japanese-style decorations. According to the caption, "M. Imafuji amid the oriental decorations which he has constructed out of scrap lumber in his barracks home at Heart Mountain. Though he enjoys surroundings, reconstructed from memory of his early childhood, Imafuji's devotion to Americanism is tested by his American Legion membership and his service with the A.E.F."[22] In this photograph and caption, the WRA unravels the conflation of the Japanese enemy with the Japanese American and tries instead to carve out a space in which Japanese cultural practices could be a part of a patriotic American identity.

While American cultural practices like high school dances were encouraged inside the camp, Japanese cultural practices also seem to have been prominent. Manbo photographed both kinds of events. His lens recorded a parade, steeped in the iconography of the United States, with the leader in a Boy Scout uniform holding up the Stars and Stripes and a drum majorette in a white miniskirt and white boots behind. (See page 50.) At a different time, Manbo took several photographs of

a sumo tournament. One image offers a light-hearted moment, with the smiles of two sumo wrestlers echoed in the faces of the crowd watching behind them. (See page 59.) Eric Muller explains that the WRA allowed for a kind of cultural pluralism that the military would have characterized as un-American. He writes:

> Military and civilian agencies differed sharply over the extent to which outwardly "American" cultural practices and a willingness to submit to repression were preconditions for membership in the American polity. . . . [That] some wartime bureaucrats managed to sustain an idea of Americanism that tolerated cultural difference even minimally and allowed even a little space for dissent is noteworthy. That fact suggests that the door of a more multicultural and tolerant Americanism, long thought tightly closed in the years before and during the war, was already at least a bit ajar.[23]

The door was ajar, but this does not mean that the WRA gave equal support to American and Japanese cultural activities. According to an article in the *Gila News-Courier*, the WRA was able to modestly support Japanese cultural endeavors: "While no restriction of voluntary participation of the residents in Japanese style games, sports and cultured activities of a non-political nature is intended, the WRA can give very limited patronage to these activities." That support included no more than one paid instructor for each activity. American cultural activities by comparison were given much greater WRA sponsorship, as the paper noted this was "in

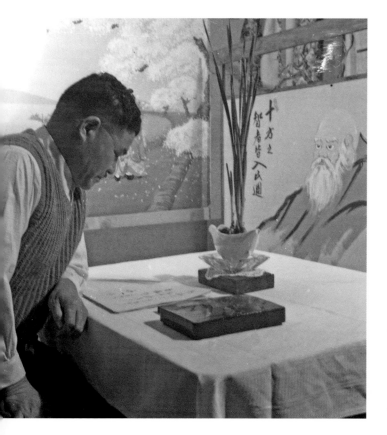

Photograph by WRA photographer Tom Parker depicting a Japanese American man in his Heart Mountain barrack in August 1943. Courtesy of the National Archives, photo no. 210-G-B893.

line with its [WRA's] primary object of restoring evacuees to their normal place in American life."[24] Interestingly, this article appears just below one that announces the camp's Bon Odori festival, with 350 dancers scheduled to participate.

If we look back at Manbo's Bon Odori photograph on page 82, the coexistence of the Japanese and the American is perhaps best expressed in the cereal boxes that adorn a dancer's costume. With the importance of rice in the Japanese diet, it is particularly ironic that the words "Rice Krispies" taken from boxes of the processed breakfast food repeat three times across the dancer's chest. In her novel *When the Emperor Was Divine*, Julie Otsuka beautifully captures a similar cultural mix inside a Japanese American home on the eve of the forced removal. On the day that Otsuka's character, referred to only as "woman," prepares for her family's move to camp, she removes a reproduction of Jean-François Millet's painting *The Gleaners* from the wall and listens to Enrico Caruso on the radio while she eats rice balls stuffed with pickled plums, then feeds the pet dog for the last time.[25] In her daily life, through her consumption of art, music, and food, "woman" demonstrates a kind of cultural integration that denies the assumption behind the evacuation orders: the incompatibility of East and West.

As David Yoo writes, "In their day-to-day lives, Nisei moved between many spheres and occupied multiple identities; hence, it makes little sense to argue for an authentic self that somehow was either Japanese or American. The more compelling question . . . is to ask how Nisei negotiated the complexities of identity formation in the toss and tumble of their times."[26] In the toss and tumble of his time at Heart Mountain, Manbo used his camera to construct a sense of self as observer, as well as a sense of family and community. Manbo's photographic gaze framed a wide variety of activities and scenes in Heart Mountain that allowed him to author an experience that has been described as humiliating, emasculating, and supremely unjust. His camera was the tool he used to control a world in which his autonomy had been denied along with his citizenship rights. If the camera was a means for Manbo to articulate an assertion of citizenship, other Nisei used different tools to make similar claims; from volunteering for the military to protesting the suspension of their constitutional rights. Manbo's lens stays largely away from these more political acts of citizenship, and he does not document what has come to dominate historical discourse about Heart Mountain: the Fair Play Committee and the resistance to the draft.[27]

In addition to photographs of cultural activities inside Heart Mountain, Manbo also focused his lens lovingly on his own son. The photographs of Billy have all the poignancy that any photograph of youth lost to time might have. The photographs attest to the childhood that Billy carved out for himself and that his father so clearly cherished. Most often we see Billy at play. Crouched facing a model airplane as long as he is tall, young Billy is properly outfitted for his aeronautic play with a leather flying cap and jacket.[28] Billy holds the propeller in both hands preparing for flight. In a particularly endearing image of play, Billy sits on the barren earth of Heart Mountain with one leg extended and one leg tucked in as he peers down at some

treasure in his hands, perhaps a marble. Another boy sits across from him, mirroring the focus and wonder. Billy wears a garrison cap jauntily cocked on his head.

When Roland Barthes meditates on photography in *Camera Lucida*, he writes of many different kinds of images, but the most powerful one for him personally is a snapshot of his mother as a child. Looking to photographs for a way to remember his deceased mother, Barthes fixates on one with her as a five-year-old and writes, "For once, photography gave me a sentiment as certain as remembrance. . . . The Winter Garden Photograph was indeed essential[;] it achieved for me, . . . *the impossible science of unique being*."[29] The photograph provoked an emotional response, quite different from the analytical readings Barthes gives advertising or journalism photographs, and that response demonstrates the power that these everyday photographs have. Vernacular photographs of children and families can operate as surrogate selves and as such represent not just subjects but human relationships over time. Photographs of children may be common, but the accretion of time and evocation of promise that overlay their surfaces laden them with poignancy. Though part of a relentlessly nostalgic genre, Manbo's photographs of his son complicate the sense of longing with an iconography of barracks and barbed-wire fences that connote the injustice of Billy's imprisoned childhood.

A document in the Manzanar archives at UCLA tells the story of a young Nisei mother who lamented her lack of access to a camera while she was incarcerated, not because she wanted to record the substandard conditions in which she lived, but because she could not document the growth of her only daughter. Manzanar was inside the Western Defense Command, so the access that Bill Manbo had to cameras did not extend to this Nisei mother. She writes, "Here our children are getting older, day by day, and once their childhood is gone, nothing on this earth can bring it back, and if we have no mementos of their growth, we feel cheated and a little bitter to think that just a snapshot now and then, even if it was taken in a 'concentration camp,' is better than nothing at all."[30] Most Japanese Americans have a large gap in their family albums. Where photographs of weddings, baseball games, and prom dates should be, the pages are largely empty. Bill Manbo's photographs allow us to repopulate those pages with family portraits, children playing, and other scenes of daily life and recognize the significance that photographs play in everyday acts of self-representation.[31]

The images of Billy at play reveal the dislocated normality that parents faced in their efforts to secure a nurturing childhood environment. Billy learned to ice skate at Heart Mountain, and his father photographed him skating confidently on double-bladed skates, wearing ill-fitting gloves and a watch cap. (See page 49.) At a slightly warmer time of year, Bill took his son to the edge of camp and positioned him at the barbed-wire fence. In one close-up variant, Billy's little hands close around the wire in between the barbs and he rests one foot on the bottom wire. He gives a faint kind of smile, and behind him is a long row of blurry barracks. (See page 70.) In another, the photographer backs up a bit, so as his son is perched on the fence, the viewer gets a fuller sense of the land-

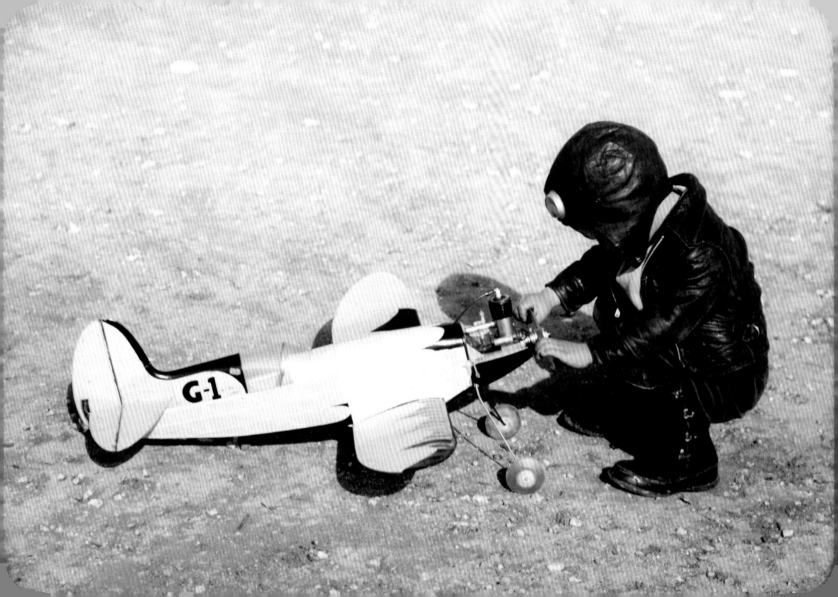

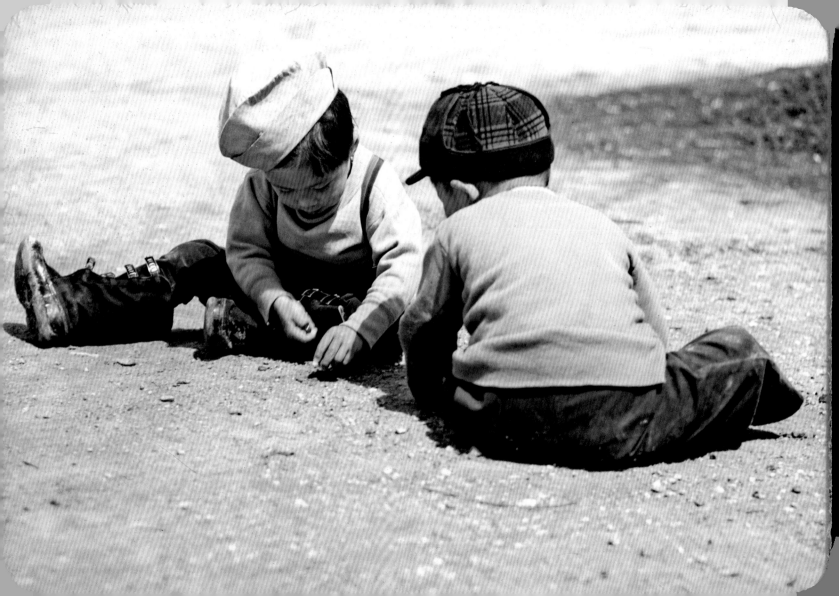

scape behind him, where barracks really extend as far as the eye can see. (See page 66.) A few pedestrians are scattered in the wide unpaved road along with a couple of cars, and to the boy's left sits a yellow fire hydrant.

The photographs of Billy at the barbed-wire fence make an apt comparison with Toyo Miyatake's well-known images of three boys standing at the barbed-wire fence in Manzanar. Miyatake's photographs have the deliberate sense of composition that would accompany his status as a professional photographer who used a view camera. Manbo's camera was a much more portable but no less professional thirty-five-millimeter Zeiss Contax camera. This camera was a highly regarded piece of equipment—Ansel Adams had one at the time. Compared with the more informal views of Manbo, Miyatake has carefully thought out issues of vantage point and perspective. His lens is down at the eye level of the boys to communicate empathy with their unfair incarceration. The diagonals created by the retreating barbed wire guide the viewer's eye through the space of the picture plane, from the boys to a guard tower and then to the mountains beyond. Manbo takes a much more straightforward approach, setting up the shot to emphasize frontality through the position of the fence and his son. His son's expression and gaze straight back at the camera create an image that is more of a portrait than a metaphor. Miyatake's subjects look away from the lens as if they are unaware of the camera's presence and their gazes beyond the confines of camp function symbolically to communicate injustice. The barbed-wire fence was also a charged symbol in Heart Mountain. According to the *Heart Mountain Sentinel*, residents gave WRA director Dillon Myer petitions with more than 3,000 signatures asking for the removal of the fences and watchtowers. The complaint pointed to the lack of freedom and "ill feeling" the fence engendered.[32] Both Issei and Nisei signed the petitions, which argued that the WRA had maintained that they were not prisoners, an assertion the fences and guard towers contradicted.

Despite their ubiquity, vernacular photographs such as Manbo's have not received the same level of scholarly attention that photographs made purposely as social documents or artistic works have. In the last decade or so, art museums and art his-

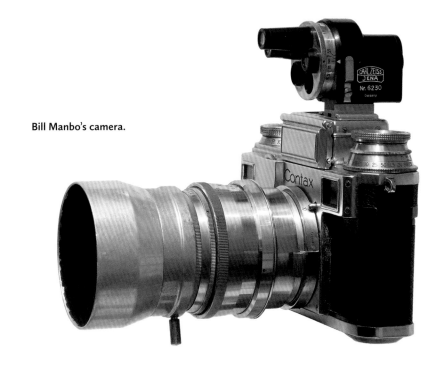

Bill Manbo's camera.

Photograph by Toyo Miyatake of three boys behind a barbed-wire fence at Manzanar in 1944.
Courtesy of the Toyo Miyatake Manzanar Collection.

torians, as well as artists, have turned to vernacular photographic production to think more broadly about the significance of the snapshot.³³ The work of Bill Manbo gives us an opportunity to examine the consequence of vernacular photographs made inside an American concentration camp. While scholars, including myself, have written extensively on the work of professional photographers assigned to document the camps, Manbo's photographs have flown under the radar, as the slides remained tucked away in boxes in his son's house. What is fascinating about Manbo's work, and vernacular photography in general, is how the images often seem to operate between categories. Manbo's photographs lack the overt political impulse that characterizes Dorothea Lange's style of social documentary. Nor do they have the propagandistic zeal of Ansel Adams's images of the incarcerated in Manzanar. Even Toyo Miyatake's photographs of personal rites of passage have the more distanced feel of a professional portrait photographer.

Bill Manbo's images, however, seem like something else. Something more familiar, in part because all of us have images of childhood, of celebrations, of found beauty, in the pages of our family photo albums. Despite their ordinariness, vernacular photographs are compelling because the representation of self (in the larger sense of family) is expressed as a fundamental right. And it was that very right to photographic representation through the right to the camera that WRA regional director Joseph Smart articulated when he requested the relaxation of the contraband rules in camps outside of the Western Defense Com-

mand. Without this argument by Smart that "people should be permitted to have a photographic record of their lives," the camera would not have ended up back in Manbo's hands. The next questions are how many other Manbos were there in the camps and where are their photographs?

NOTES

1. For a fuller account of roles that the camera played in the incarceration experience, see my *Moving Images: Photography and the Japanese American Incarceration* (Urbana: University of Illinois Press, 2009). See also Elena Tajima Creef, *Imaging Japanese America: The Visual Construction of Citizenship, Nation, and the Body* (New York: New York University Press, 2004), 13–70.

2. Takao Bill Manbo, interview by Eric Muller, Los Alamitos, Calif., July 19, 2010.

3. Dorothea Lange documented the forced removal from Northern California and focused on its injustice by picturing Japanese American assertions of U.S. citizenship and patriotism, including the posting of a large sign that read "I am an American" on a storefront in Oakland. For more on Lange, see Linda Gordon and Gary Y. Okihiro, eds., *Impounded: Dorothea Lange and the Censored Images of Japanese American Internment* (New York: W. W. Norton, 2006); and Roger Daniels, "Dorothea Lange and the War Relocation Authority," in *Dorothea Lange: A Visual Life*, edited by Elizabeth Partridge (Washington, D.C.: Smithsonian Institution Press, 1994), 46–55.

4. I am grateful to Eric Muller for finding these documents and sharing them with me.

5. Letter from Joseph Smart to Dillon Myer, October 26, 1942. Records of the War Relocation Authority, Record Group 210, "Classified General Files," Box 228, National Archives, Washington, D.C.

6. Ariella Azoulay, *The Civil Contract of Photography* (Cambridge: MIT Press, 2008), 117.

7. Eiichi Sakauye recalls requesting that the project director at Heart Mountain send a letter demanding that Japanese Americans be allowed to use cameras. See Eiichi Sakauye, *Heart Mountain: A Photo Essay* (San Mateo, Calif.: Asian Amer-

ican Curriculum Project, 2000), 5. While I have not found archival evidence to support or deny that claim, it points to an act of memory in which Japanese American agency is tied to the effort of returning the camera to Japanese American hands.

8. "Defense Command Releases Contraband: Claimants Classified in Three Categories," *Granada Pioneer* (Amache, Colo.), October 30, 1943; "Contraband Ruling Eased," *Denson (Ariz.) Tribune*, June 8, 1943.

9. According to a "Coordinator's Bulletin" from Heart Mountain dated March 7, 1945, Issei, or "Aliens" as the documents state, would not be allowed to have contraband released to them even as the camps were winding down (Heart Mountain closed in November 1945). Cameras remained on that contraband list along with firearms, bombs, and short-wave radios.

10. The Anaheim Public Library's description of the photograph states: "Heart Mountain Internment Camp, Camera Club—George Hirahara is second from left in the back row and Bill Manbo is standing to his right. This photograph was taken in the early spring of 1944." Given his apparent enthusiasm for photography, one might assume that Bill Manbo would have been a member of a camera club before the war, but there is no evidence to support that assumption. Bill Jr. recalled that his father's photographic hobby was confined to his incarceration years. Takao Bill Manbo, interview by Eric Muller, Los Alamitos, Calif., July 19, 2010.

11. Takao Bill Manbo, e-mail to Eric Muller, January 20, 2011.

12. Lane Ryo Hirabayashi, *Japanese American Resettlement through the Lens* (Boulder: University of Colorado Press, 2009), 18–20.

13. Ibid., 174–75. Lane Hirabayashi selected these two photographs as some of his favorites by Iwasaki because they show "daily acts of creative, subjective assertion." Ibid., 174.

14. One caption states: "Granada Relocation Center, Amache, Colorado. Part of the approximately 1,000 dancers who participated in the Bon Odori festival sponsored by the Granada Buddhist Church on August 14. Spectators are shown in the background. This dance was held at night on the baseball diamond." This photograph by Joe McClelland is in the Records of the War Relocation Authority, Record Group 210, National Archives, College Park, Md.

15. Denver Field Office, Record Group 210, Box 5, National Archives, Washington, D.C.

16. For more on WRA captioning, see Alinder, *Moving Images*, 36–42.

17. Takao Bill Manbo, interview by Eric Muller, Los Alamitos, Calif., July 19, 2010.

18. Quoted in John Dower, *War without Mercy* (New York: Pantheon, 1986), 80.

19. Colonel Karl R. Bendetsen, quoted in Caleb Foote, *Outcasts! The Story of America's Treatment of Her Japanese-American Minority* (New York: Committee on Resettlement of Japanese Americans, n.d.), n.p.

20. Quoted in Foote, *Outcasts!*, n.p.

21. Letter to Ralph Palmer Merritt from unspecified prisoner, 18-2-3, April 23, 1945, located in unbound copy of *Final Report, Manzanar Relocation Center*, vol. 1, *Project Director's Report Supervised by Robert L. Brown*, Folder 1, Box 4, Manzanar Records, Special Collections, UCLA.

22. The photograph is in the Records of the War Relocation Authority, Record Group 210, National Archives, College Park, Md. "A.E.F." likely refers to the American Expeditionary Forces sent to Europe in World War I.

23. Eric Muller, "Americanism behind Barbed Wire," *Nanzan Journal of American Studies* 31 (2009): 14–15.

24. "WRA Unable to Support Oriental Rec. Activities," *Gila News-Courier* (Rivers, Ariz.), July 17, 1943.

25. Julie Otsuka, *When the Emperor Was Divine* (New York: Anchor, 2002), 9.

26. David K. Yoo, *Growing Up Nisei: Race, Generation, and Culture among Japanese Americans of California, 1924–1949* (Champaign: University of Illinois Press, 2000), 5.

27. Heart Mountain was a particularly active site for draft resistance. While the Fair Play Committee initially formed in 1943 to protest the illegality of incarceration, it grew in response to the news in January 1944 that the draft would be reinstated for Nisei. Douglas W. Nelson, *Heart Mountain: The History of an American Concentration Camp* (Madison: University of Wisconsin Press, 1976), 118–50.

28. In 1958, after he graduated from high school, Billy—known as an adult as "Bill"—joined the Air Force. Takao Bill Manbo, interview by Eric Muller, Los Alamitos, Calif., July 19, 2010.

29. Roland Barthes, *Camera Lucida: Reflections on Photogra-*

phy, trans. Richard Howard (New York: Hill and Wang, 1981), 70–71.

30. "A Nisei Mother Looks at Evacuation," Community Analysis Section, Manzanar Relocation Center, 26 October, 1943, Folder 2, Box 7, Manzanar Records, Special Collections, UCLA.

31. The demand for professional portrait photography at Heart Mountain was great enough for a photographer from a studio in Byron to come set up shop once a week inside the camp. "Photographer Will Be in Center Every Wednesday," *Heart Mountain (Wyo.) Sentinel Supplement*, May 30, 1944.

32. "Protest Petition Sent to WRA Director: Removal of Barbed Wire Fence Asked," *Heart Mountain (Wyo.) Sentinel*, Saturday, November 21, 1942.

33. Examples of such work include Richard Chalfen, *Turning Leaves: The Photograph Collections of Two Japanese American Families* (Albuquerque: University of New Mexico Press, 1991); Geoffrey Batchen, "Vernacular Photographies," in Batchen, *Each Wild Idea: Writing, Photography, History* (Cambridge: MIT Press, 2001), 57–81; Deborah Willis and Brian Wallis, *African American Vernacular Photography: Selections from the Daniel Cowin Collection* (New York: International Center of Photography, 2005); and Catherine Zuromskis, "Ordinary Pictures and Accidental Masterpieces: Snapshot Photography in the Modern Art Museum," *Art Journal* 67, no. 2 (Summer 2008): 105–25.

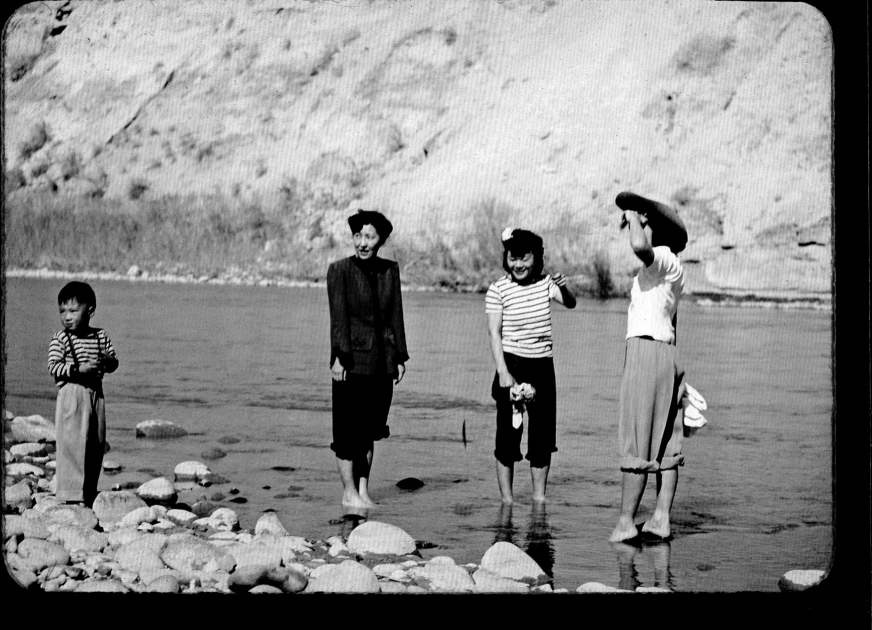

Unexpected Views of the Internment

LON KURASHIGE

In 1943 a Wyoming boy was afraid of the Japanese who suddenly appeared near his small town. There were thousands of them, Alan Simpson recalled, and they lived in a camp enclosed by barbed wire and armed guards. When told that his Boy Scout troop would visit the newcomers at the Heart Mountain internment center, the thirteen-year-old gasped, "I don't want to go out there[;] we could all be killed."[1]

Simpson was one of countless Americans who believed that the confinement of more than 110,000 Japanese Americans proved they were a danger to national security. Today, a large and growing number of books, films, websites, and museum exhibits document the error of this belief, as well as its devastating consequences for the internees and the nation's democratic tradition. But what gets little, if any, attention in these accounts is how some Americans developed a more sympathetic view of the internees after becoming familiar with their plight. This is exactly what happened to the young Simpson when he reluctantly visited the Heart Mountain camp. Much to his surprise he made a friend who would inspire a lifelong desire to make amends for one of the nation's worst violation of civil liberties.

The boy Simpson befriended at Heart Mountain was Norman Mineta, and thirty years after meeting each other they reunited on Capitol Hill, as members of the U.S. Congress. Simpson, a conservative Wyoming Republican, and Mineta, a liberal California Democrat, became bipartisan advocates for "redress" legislation that apologized for the internment and authorized paying restitution to its living survivors. But the redress victory did not stop Simpson and Mineta from continuing to shed light on the wrongs of internment; in their retirement they returned to where their friendship began to establish an interpretive center for the Heart Mountain camp.

This essay examines the photographs of Bill Manbo featured in this book in light of the conditions at Heart Mountain that enabled Simpson and Mineta to forge such a meaningful and lasting bond. The photographs, like the boys' friendship, invite one to appreciate unexpected views of the internment experience. Such views were made possible by the split personality of the War Relocation

Authority (WRA), the federal agency that in March 1942 began to gradually take over from the military responsibility for the vast majority of Japanese American internees. While the WRA camps were certainly places of victimization, they were run by administrators who were not simply victimizers. In fact, Kevin Leonard sees the WRA's advocacy for its charges as a kind of twentieth-century abolitionism, because "not since the Freedmen's Bureau had a federal agency worked so diligently to improve race relations."[2] Thus the Manbo photographs are important not just for their remarkable color but also for allowing students of the internment to recognize the many shades of gray needed to understand the WRA's curious role as both protector and jailer of Japanese Americans.

Beyond "Concentration Camps"

From the 1970s to the 1990s there was a national debate over whether to use the term *concentration camps* or the WRA's official and more benign *relocation centers* to characterize the sites where the internees were held during World War II. According to Alice Yang Murray, *concentration camps* was pushed because of its shock value; the phrase, no matter how qualified, linked the confinement of Japanese Americans to Nazi extermination camps. Associating the internment with concentration camps, she argues, was done to draw attention to the "oppressive aspects of the American camps and to provoke reflection on the meaning of incarceration." In her own study of the internment, Murray shied away from using *concentration camps* because she was less interested in provoking readers than in

educating them about the diversity of internment memories—not all of which, I would add, focused on racism, suffering, and oppression.[3]

The harsh view of the internment Murray reckoned with gained popularity during the late 1960s, when social activists sought to shock the Japanese American community out of political complacency. They were aided by professional historians, especially Roger Daniels, author of *Concentration Camps, USA*, and tireless advocate for exposing anti-Japanese racism. Daniels's research—along with separate studies by Michi Weglyn and Peter Irons—encouraged the formation of a grassroots campaign pushing Congress to pay reparations to the former internees. The campaign grew into the full-blown redress movement, featuring leadership by U.S. Congressmen Norman Mineta and Robert Matsui, as well as Senators Spark Matsunaga and Daniel Inouye. Backed by these friends on Capitol Hill, the Congressional Commission on Wartime Relocation and Internment of Civilians paved the way for redress by finding that the internment resulted from "race prejudice, war hysteria, and a failure of political leadership." The enactment of redress legislation, however, was never guaranteed. Vocal opposition arose during the early days of the redress campaign and gained national recognition when congressional conservatives sought to kill the measure. Even President Ronald Reagan opposed it—only to change his mind by signing the redress legislation when it passed both houses of Congress in 1988.[4]

The politics of redress polarized historical debate about the internment during the 1970s and 1980s. The conservative opposition questioned

the congressional commission's findings, while professional historians unanimously supported them. With redress legislation at stake, scholarship on the internment tended to serve the utilitarian functions of righting past wrongs and building civil rights coalitions. Consequently, the redress victory raised the profile of this kind of utilitarian scholarship. But at the same time it enabled a younger generation of researchers, such as Alice Yang Murray, to think beyond the strategic needs of a policy campaign.

The first sign of the new direction in internment research emerged one year after the passage of redress with the publication of *Views from Within: The Japanese Evacuation and Resettlement Study*, edited by the well-respected historian of Japanese immigrants Yuji Ichioka. The book consisted of eleven essays and reflections wrestling with the legacy of a University of California, Berkeley, social science project that studied the internment "from within" as it was happening. The vast majority of contributors to *Views from Within*, while critical of the wartime study, drew a nuanced and sensitive picture of the project. Ichioka spoke for most of the contributors in appreciating the social scientists' detailed descriptions of camp life. To him, they offered a treasure trove from which historians could create a "rich social history of concentration camp life." In this way, *Views from Within* turned the spotlight away from government misdeeds and toward the diversity of internee experience.[5]

Reviews of the Ichioka collection revealed an emerging divide among professional historians. On the one hand, Roger Daniels, the leading figure in the utilitarian mode of internment history, strongly criticized the Berkeley project social scientists for not speaking out during the war about the "rank injustice of the removal and incarceration of Japanese Americans." His criticism extended to *Views from Within*, whose essays, he noted, ignored this conspicuous silence among the social scientists. On the other hand, reviewers more interested in the diversity of internee experiences, such as leading Japanese historian Akira Iriye, praised the social scientists for producing copious primary sources revealing the rich details of Japanese American life.[6]

The two modes of scholarship, utilitarian and diversity, could exist side by side, complementing each other. Daniels himself blended the two in his own synthesis of Asian American history, as did Ichioka in his introduction to *Views from Within*. But while few realized it at the time, the book signaled the start of a divergence. Brian Masaru Hayashi, a participant in the UCLA conference that launched the Ichioka collection, has noted that his research on internee social scientists led him to take a "wider outlook" on the internment than was possible under the utilitarian mode of study. The publication of Hayashi's *Democratizing the Enemy: The Japanese American Internment* in 2004 marked the fullest expression of the diversity perspective to date. Hayashi, while stating unequivocally that the internment was wrong, sets it within a global context to rethink decision making by the U.S. military and civilian officials, the WRA, and the internees. A small but telling example of his "wider outlook" is that he situates the internment within the context of global responses to enemy alien populations during World War II. While the utilitarian approach focuses tightly on American racism and injustice,

Hayashi found that in "contrast to actions of politicians [regarding enemy aliens] in other countries, President Franklin Roosevelt's treatment of Japanese Americans seems relatively benign."[7]

Students of Japanese American history praised Hayashi's book for its fresh approach and its solid foundation of research. Lane Hirabayashi called it "one of the most detailed, insightful, and thoroughly documented accounts of the Japanese American experience during World War II." Hirabayashi, a contributor to the *Views from Within* collection and himself a researcher responsible for two books on internee social scientists, was a good judge of Hayashi's points. I, too, could vouch for Hayashi's study, since in researching my book on Japanese American identity before, during, and after the internment I relied extensively on the work of social scientists living at the Manzanar WRA camp. Thus by the early 2000s the diversity perspective on the internment had gained a solid foothold.[8]

It was this view of the internment that I had in mind when Eric Muller asked me to look at the Manbo photographs. Given my expertise in the longer history of Japanese American identity and culture, I figured that I could provide a reading of the photographs that paid attention to what came before and after the internment. But the main reason I agreed to write this essay is because I saw it as an opportunity to share the insights of a new generation of scholarship that is rethinking the narrow, overly harsh perception of the internment. I am familiar with this perception through the hundreds of students I have gotten to know as

a university instructor for the past twenty years. While many of them were not familiar with the internment, most were not surprised to learn about it because they had already been socialized to expect the worst from the American government. This type of cynicism, no matter how well intentioned, is dangerous because it prevents a balanced search for historical truth. Thus, the goal of this essay is to challenge cynical views of the internment by interpreting the Manbo photographs through a fresh angle of vision that is becoming increasingly prominent in historical research.

One way of reading the Manbo photographs is to argue that they are a commentary against the racism of the WRA. This view would match Richard Drinnon's dark portrayal of WRA director Dillon S. Myer. In *Keeper of Concentration Camps*, Drinnon compares Myer's role during World War II with his subsequent service as head of the Bureau of Indian Affairs and situates both within a "common matrix" of American racism. Myer appears in the book as a faceless, middle-level bureaucrat whose good intentions "generated much misery."[9] Drinnon evokes the image of barbed wire to underscore the WRA camps' draconian restrictions on internee freedom. "Inmates," he asserts, "climbed over and crawled under the wires at the risk of being shot by a bored or trigger-happy sentry."[10]

And yet the many depictions of watchtowers and fences that appear in Manbo's photographs reveal more than the internees' lack of freedom. The most poignant portrays Manbo's young son Billy playfully climbing on the perimeter fence, little hands gripping the barbed wire between

spikes. (See page 66.) This shot gives no indication that the boy, or his father the photographer, feared being gunned down by a sentry. The boy's insouciance makes sense when one considers that the camp barracks are behind him, which means that the photographer stood *outside* the barbed-wire fence. Why would the boy worry about violating the camp boundary when he had just watched his father pass through it? Clearly, at this point in time the interior boundary fence where Billy is playing was not the militarized barrier, manned by "trigger-happy" guards, that Drinnon describes. In fact, the camp administration, as early as late winter 1942, permitted internees to roam freely from "sunrise to sunset" within the vast lands between the camp's interior fence and its unguarded exterior barrier. The camp newspaper implied that the WRA was less concerned about internees escaping from camp than it was about their safety from unexpected bad weather in the area's rugged environment.[11]

Other Manbo photographs contradict the oppressive image of the barbed-wire fence by showing internees on their own recognizance outside the camp perimeter. No white chaperones are seen in many shots of internees on excursions in the nearby hills overlooking the camp. Nor are any depicted in the photographs of outings to nearby Yellowstone National Park. The camera, as it turns out, did not lie; Bill Manbo's "Evacuee Case File" in the National Archives indicates that he took two trips to Yellowstone, one requiring that he be accompanied by a white chaperone and another that explicitly notes he did not require supervision. Bacon Sakatani's account in this book, in which he

recalls with great fondness a trip to Yellowstone, confirms that it was not difficult for internees to obtain passes to leave the camp unaccompanied by military guards.

Why would the WRA allow suspected enemy aliens and their children to roam free outside the concentration camp? The answer lies in the fact that the agency's leaders did not see the vast majority of internees as a threat to national security. The WRA's general inclination was to be sympathetic toward Japanese Americans. Dillon Myer consistently opposed the military's assumption of Japanese American disloyalty. He addressed this point most forcefully in his "inside story" of the internment, which documents the WRA's "continuing battle of the racists." The battle matched Myer against the WRA's persistent and powerful critics, who opposed its "coddling" of internees. Such critics included members of Congress, the American Legion, and the national press. According to Myer, the WRA struggle paid off because the American people showed the world that "we can rise above sordid hate and bitterness of racial antipathy and the discriminatory practices stemming therefrom."[12]

Here we find Myer patting himself on the back as a savior of American democratic values. The utilitarian critics of the WRA dismiss this portrayal as no better than self-serving propaganda. The truth, as Murray deftly reveals in her study of changing internment memories, is somewhere in between the view of him as savior or hypocrite. She reveals that Myer changed his view of internees' loyalty depending on the circumstances and audience. While

In September 1943, Bill Manbo was granted leave to accompany a work group to Yellowstone National Park to pick up some abandoned structures. Here the group stops near a thermal area. A wisp of steam can be seen streaming from a cone in the distance.

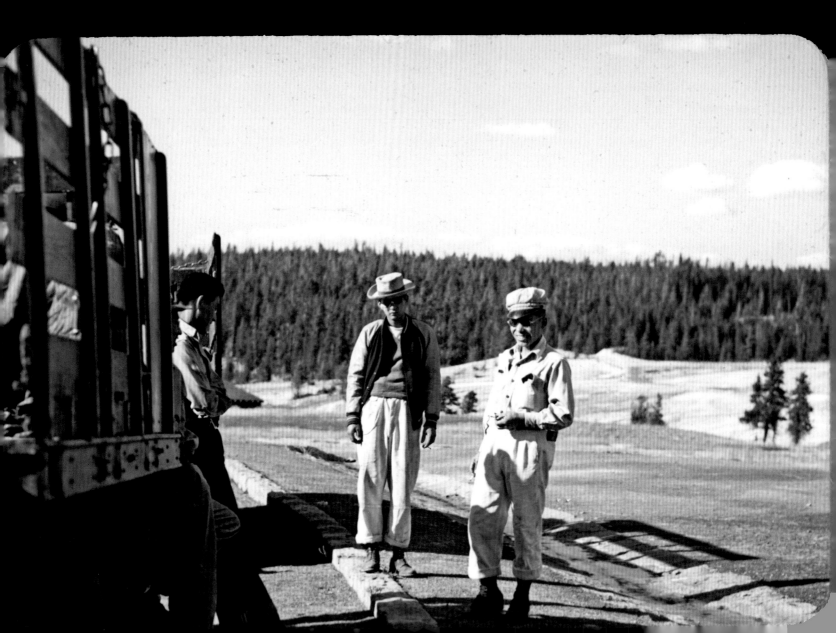

defending them against the "racists," he also agreed with the military that they were a danger to national security. The reality was that Myer, like other liberal public figures in the 1940s, was a pragmatist whose sympathy for the internees was tied up with changing political and international circumstances during World War II.[13]

The WRA's upper-level administrators shared Myer's pragmatic sympathy for the internees. In a public address in October 1945, Robert Cozzens, the agency's assistant director, identified the challenges faced by antiracists in America seeking to help the internees. "Those of us," he said, "who recognize the constitutional demands for political and economic equality of all men must also recognize that there are elements among us who adhere to a long-rejected doctrine that this is a white-man's country."[14] In addition, Brian Hayashi has uncovered records of other WRA administrators—including Wade Head and John Collier at Poston, and Solon Kimball and E. R. Fryer at Manzanar—who were even more committed antiracists than either Myer or Cozzens. Yet the most consistently progressive and sympathetic advocates for the internees were the white social scientists the WRA hired, or allowed to operate within the camps as neutral observers, ostensibly to help the agency create policies reflecting the internees' perspectives. Most of these social scientists relied on new theories that rejected the notion that blood (race) influenced one's loyalty or character.[15]

In calling attention to the antiracism of the WRA's upper administration, I am not suggesting that the agency made no mistakes in managing the internment or that the military personnel (such as armed sentries) at the camps were equally sympathetic to the internees. Clearly, Myer badly mishandled the WRA loyalty questionnaire that was supposed to clear internees of suspicion but ended up outraging and ostracizing thousands of innocent victims who were segregated in the notorious Tule Lake prison camp for "troublemakers." And yet I am arguing that an accurate portrayal of the WRA needs to recognize that its leaders did not see themselves as concentration camp commandants and that their policies did not simply cause "misery" for the internees as the WRA's critics would have us believe.[16]

Consider the WRA's resettlement program. While Drinnon faults the agency for its assimilationist goals and constant monitoring of "freed" internees, he plays down its crucial efforts on behalf of the former internees to secure jobs, housing, and college enrollment outside the West Coast exclusion zone. Moreover, after the exclusion ended, the WRA field offices in Los Angeles, Chicago, and many other cities acted as government-sponsored civil rights agents for Japanese Americans. When a Nisei veteran faced housing segregation in Southern California, WRA field workers arranged for top U.S. military leaders to speak out against the racist treatment. In this capacity, Roger W. Smith, commander of the famed 442nd all-Nisei battalion, defended one of his former men against white residents of Orange County, California. "We thought we closed the deal when we finished the war on both fronts," Smith said, "but this is rather debatable when some of the things for which we fought are being attacked here at home."[17]

The seeming contradiction of the WRA as

protector and jailer of the internees needs to be understood in the context of the modern world's fastest and most fundamental shift in racial thinking. World War II, as historian Gary Gerstle maintains, proved to be a powerful engine improving American views of racial difference and citizenship. The federal government went into the war upholding the effects of white supremacy throughout the nation, including the discriminatory exclusion of Asian immigrants. Yet it came out with a new distaste for racism that contributed to the end of Asian exclusion and the start of major civil rights achievements for women and racial minorities.[18] In other words, a world war marked by the most intense and destructive racism in modern history also gave rise to the era's most powerful momentum for civil and human rights. Nearly all of the major laws discriminating against Japanese Americans were discredited, if not repealed, within a decade after the war ended.

WRA Cultural Pluralism

Despite their antiracist stance, WRA administrators expressed different opinions about the value of Japanese culture for the process of Americanization. Most of them, following Dillon Myer, believed that "cultural baggage" inhibited an immigrant group's Americanization and thus acceptance in white America. Others, influenced by Bureau of Indian Affairs director John Collier, argued that ethnic culture should be maintained because it aided Issei and Nisei Americanization.[19] Not surprisingly, the WRA director's assimilationist view exerted the greater influence in the agency. As a result, the WRA sought to break down bonds of Japanese culture by scattering released internees across the nation and requiring them to avoid frequent contact with each other. These instructions were designed to prevent the reconstruction of the much dreaded ethnic enclave.

Many historians and former internees criticize the WRA's resettlement policy as a form of coerced Americanization. They argue that in seeking to uproot Japanese American culture the agency enacted a form of cultural genocide subjecting released internees to a draconian system of surveillance.[20] This criticism, I think, conceals as much as it reveals. It is true that Myer's failure to respect the internees' culture exposed the limits of his racial imagination. But his critics show their own limitations by failing to appreciate the WRA's assimilationist policy as an antiracist response to the long history of Yellow Peril rhetoric. Furthermore, the critics assume wrongly that the WRA's assimilationism was monolithic.

Two different historians find that the agency did not see Japanese culture as anathema to good Americanism. Brian Hayashi makes this point from a careful study of key WRA administrators, while Eric L. Muller observes it by studying the agency's adjudication of internee loyalty.[21] The WRA's tolerance for Japanese culture was consistent with the concept of cultural pluralism emerging in the first half of the twentieth century. Its origins are attributed to University of Wisconsin professor Horace Kallen, who argued that American culture should not be a melting pot but a kaleidoscope of different cultures, values, and traditions.[22] Cultural pluralism became a mainstay of anthropological research

and a cornerstone of the U.S. government's Native American policy under John Collier's Bureau of Indian Affairs.[23] It came to the WRA through the many administrators and social scientists who were experienced in Native American affairs. These upper-level administrators included Solon Kimball and Roy Nash at Manzanar and Alexander Leighton and his entire research staff at Poston's Bureau of Sociological Research. Moreover, Collier, who lobbied unsuccessfully to become WRA director, played a role in the WRA by initiating Poston's research bureau dedicated to understanding Japanese culture. Had Collier become the director, cultural pluralism surely would have played a greater role in the agency's decision making. But even with assimilation theory as the agency's lodestar, there was still a presence of cultural pluralism in the camps.[24]

The Manbo photographs provide evidence of this presence by capturing internees performing Japanese folk dances. Such dancing was a common feature of prewar Japanese American communities, especially as part of the summer ritual of Obon (a commemoration of ancestors). Yet it is not widely known that this Buddhist ritual survived in the camps. In fact, given the WRA's assimilationism, which banned Japanese practices in "American" spaces such as the camp's high school gymnasium, it is surprising to see such an open and popular expression of Old World tradition. The Obon, moreover, was not a makeshift, spontaneous action catching camp administrations unawares. Rather, it appears from the photographs that the planners took great care in reproducing the ritual. The vast majority of participants wore appropriate costumes, including kimonos with makeup and accessories for the feet, hair, and hands. The decorated ritual space featured an elaborately constructed central platform around which the internees performed their dances.

The Buddhist aspect of Obon adds another layer of complexity, given that U.S. intelligence deemed Japanese Buddhist ministers especially untrustworthy, removing them to special Justice Department camps far away from their families and the bulk of the internees. Did Heart Mountain administrators see the observance of Obon as consistent with internee Americanization? The same question can be asked of sumo wrestling, another form of Japanese culture featured in the Manbo photographs. As Japan's national sport, sumo was inextricably linked to Shinto, the country's national religion, which Americans associated with much maligned emperor worship. That so many internees embraced Obon dancing and sumo wrestling suggests they developed an American identity without devaluing and discarding Japanese traditions. In this way, they seemed to be practicing the kind of cultural pluralism supported by John Collier and other WRA officials. Ethnic leaders, before the war, stressed that the Nisei could be culturally Japanese and American while politically loyal to the United States. The Manbo photographs suggest that this form of cultural pluralism continued to influence behavior during the internment. The snapshots, thus, raise questions about the meaning of Japanese religions and traditions during the internment. How did the camps, despite their coerced assimilationism, continue the internees' prewar bicultural orientation?

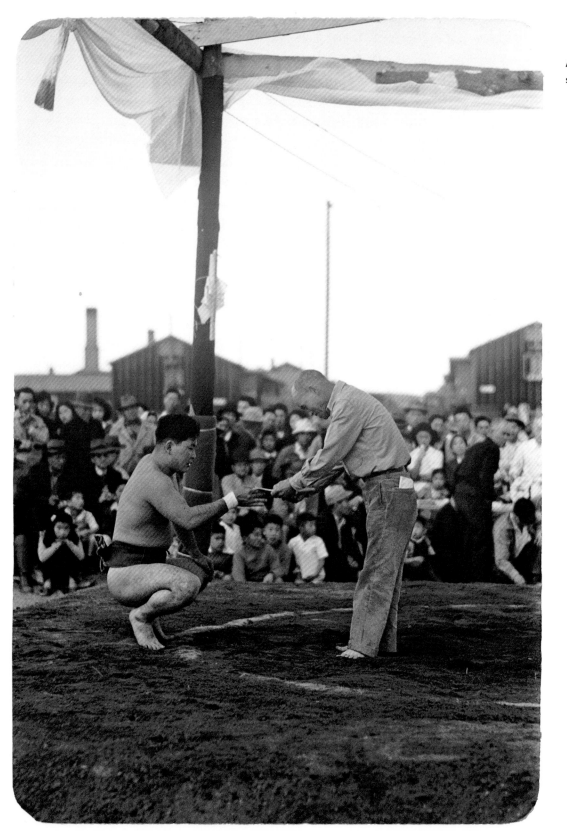

A ceremonial moment at a sumo match.

112

Greatest Generation of Nisei

The second generation played a special role in the WRA's assimilation programs. While offering English-language instruction and Americanization classes to Issei in the camps, the WRA mainly sought to reach these adults through their children. The focus was on creating an "all-American" environment for camp youth such that Boy Scouts like Norman Mineta could work on merit badges as if their lives had not changed. The Manbo photographs testify to such youth programs at Heart Mountain. Some of the shots document the camp's Boy Scout drum and bugle corps, while others reveal the broader picture of youth Americanization through quintessentially American extracurricular activities such as baseball and marching band.

Schooling, however, is missing from the Manbo photographs. This is typical, given that histories of the internment also overlook public school experiences in the camps. Fortunately, one of the few studies of this kind, written by historian Thomas James, stands as a model of historical scholarship. James's *Exile Within* portrays public education in the WRA camps as the outcome of the unlikely collaboration between the camp's strict military authority and its progressive WRA administration. The author finds that internee parents did not lose faith in American public education despite the injustices they suffered and the serious shortcomings of camp schools. Interned children, except at the more restrictive Tule Lake camp, went to school, and as a result recovered much—if not all—of the academic ground lost due to their exclusion and confinement.[25]

The true value of camp schooling should be measured by how smoothly the students transitioned when they returned to regular schools. The result, according to James, is that children resumed "relatively normal educational experiences, reflected in persistently high levels of education among younger Japanese Americans as a whole in the years after the war." That the youth kept pace, and in many cases surpassed, their noninterned peers testifies in no small way to the WRA's concern for their welfare. Indeed, the situation could have been much worse.[26]

The WRA's attempt to create a "normal" life for camp youth most likely explains why former internees often have buoyant memories of camp. Bacon Sakatani's recollection of halcyon days at Heart Mountain is not surprising. Nor is Alan Simpson's characterization of Norman Mineta: He "came through all that hardship in the camps by rising above any kind of resentment or bitterness."[27] After leaving Heart Mountain, Mineta resumed his education, graduated from the University of California, and ran a successful insurance business that launched his political career as the first Asian American mayor of a major U.S. city (San Jose, California) and later as a member of the U.S. House of Representatives. Mineta, of course, is one of the "stars" of the younger Nisei cohort who went to school in internment camps and came of age after the war. But his achievements were different in degree but not in kind because the camp youth as a whole became the most successful Nisei age cohort in terms of rate of college attendance, average income, and career status. In this way, the WRA built a solid educational foundation for what can be called the Nisei's "greatest generation."[28]

I use this well-known phrase deliberately to connect the camp youth to the World War II generation of Americans that has been lionized in recent popular memory.[29] The "greatest generation" moniker is important not just because it celebrates the nation's heroism and achievement, but also because it exposes the political ends of remembering World War II. Such hero making cuts selectively from the broad tapestry of the past to spin a morality tale about the importance of American freedom, democracy, and opportunity. In other words, the idea of the "greatest generation" simplifies the complex past into a dramatic form of patriotic expression.

Most histories of the internment do not celebrate the nation and in this way are at odds with the "greatest generation" thesis. But my point is that they, too, are political products because they simplify the complex past into a dramatic tale that furthers particular goals. The most common of these is antiracism. In this way, utilitarian histories of the internment harshly criticize the nation's racism and coercive authoritarianism in attempting to redeem its undemocratic tendencies. Such a redemption tale has required that the WRA, and government officials as a whole, play the "bad guy" role. As a result, crucial parts of the internment story are ignored or trivialized, including the WRA's antiracism, belief in the internees' loyalty, and tolerance for cultural pluralism in the camps.

The Manbo photographs provide a unique opportunity to look beyond the redemption tales told about the internment. Such tales exaggerate the dangers posed by the barbed-wire fences surrounding the camps and cast the WRA as a racist jailer that sought to strip the internees of their culture and community. The experiences of Alan Simpson, Norman Mineta, Bacon Sakatani, and the subjects of Manbo's photographic eye in their own way testify to the limitations of this harsh, black-and-white view of the WRA camps. The collection of photographs featured in this book allows us to view the internment in full, living color. By this I mean not just the literal Kodachrome slides but also the widely diverse colors of internee experience that stem from the WRA's ambivalent role as internees' protector and jailer. Placing the agency's shades of gray at the center of analysis is important because it can open up a new chapter in the study of the internment by expanding the current focus on internee misery and WRA coercion.

NOTES

1. Alan Simpson, interview, Conversations with History, Institute of International Studies, University of California, Berkeley, http://globetrotter.berkeley.edu/conversations/Simpson/simpson3.html.

2. Kevin Allen Leonard, "Years of Hope, Days of Fear: The Impact of World War II on Race Relations in Los Angeles" (Ph.D. diss., University of California, Davis, 1992), 227. Leonard's dissertation offers the most extensive analysis of WRA antiracism. This analysis appears, in part, in Leonard, *Battle for Los Angeles: Racial Ideology and World War II* (Albuquerque: University of New Mexico Press, 2006), 199–257.

3. Alice Yang Murray, *Historical Memories of the Japanese American Internment and the Struggle for Redress* (Stanford, Calif.: Stanford University Press, 2008), 7. Another recent study of the internment also chose not to use the term "concentration camp." See Greg Robinson, *A Tragedy of Democracy: Japanese Confinement in North America* (New York: Columbia University Press, 2009), viii.

4. Roger Daniels, *Concentration Camps, USA: Japanese Americans and World War II* (New York: Holt, Rinehart and Winston,

1971); Michi Weglyn, *Years of Infamy: The Untold Story of America's Concentration Camps* (New York: William Morrow, 1976); Commission on Wartime Relocation and Internment of Civilians, *Personal Justice Denied: Report of the Commission on Wartime Relocation and Internment of Civilians* (Washington, D.C.: Civil Liberties Public Education Fund, 1997 [1983]), 18. Peter Irons's book stimulated an offshoot of the redress campaign—the legal struggle to overturn the wartime convictions of Fred Korematsu, Gordon Hirabayashi, and Min Yasui, each of whom challenged the government program's constitutionality. See Peter Irons, *Justice at War: The Story of the Japanese American Internment Cases* (New York: Oxford University Press, 1983).

5. Yuji Ichioka, ed., *Views from Within: The Japanese American Evacuation and Resettlement Study* (Los Angeles: UCLA Asian American Studies Center, 1989), 23.

6. Roger Daniels, review of *Views from Within*, *Journal of American History* 77, no. 3 (Dec. 1990): 1083; Akira Iriye, review of *Views from Within*, *Pacific Historical Review* 60, no. 3 (Aug. 1991): 425. For another appreciation of the collection's contribution to the social history of the internees, see Karen Ito, review of *Views from Within*, *Journal of American Ethnic History* 11, no. 3 (Spring 1992): 91–92.

7. Roger Daniels, *Asian America: Chinese and Japanese in the United States since 1850* (Seattle: University of Washington Press, 1988); Brian Masaru Hayashi, *Democratizing the Enemy: The Japanese American Internment* (Princeton, N.J.: Princeton University Press, 2004), 6. Greg Robinson provides another version of the "wider outlook." His comparative analysis of internment in the United States, Canada, and Mexico reflects the broader focus that Hayashi uses much more than does Roger Daniels's study of internment in the United States and Canada. Compare Robinson, *A Tragedy of Democracy*; and Daniels, *Concentration Camps, North America: Japanese in the United States and Canada* (Malabar, Fla.: Krieger, 1993 [1981]).

8. The Hirabayashi quote is on the book jacket of the hardcover version of Hayashi's book. See also Richard S. Nishimoto, *Inside an American Concentration Camp: Japanese American Resistance at Poston, Arizona*, edited by Lane Ryo Hirabayashi (Tucson: University of Arizona Press, 1995); Lane Ryo Hirabayashi, *The Politics of Fieldwork: Research in an American Concentration Camp* (Tucson: University of Arizona Press, 1999); and Lon Kurashige, *Japanese American Celebration*

and Conflict: A History of Ethnic Identity and Festival, 1934–1990 (Berkeley: University of California Press, 2002), 75–116.

9. Richard Drinnon, *Keeper of Concentration Camps: Dillon S. Myer and American Racism* (Berkeley: University of California Press, 1987), xxvii, 250.

10. Drinnon refers to the April 11, 1943, killing of James Hatsuaki Wakasa by a guard at the WRA camp in Topaz, Utah. Drinnon, *Keeper of Concentration Camps*, 43.

11. "'Sunrise to Sunset' Privileges for Center Residents Planned," *Heart Mountain Sentinel*, Nov. 28, 1942.

12. Dillon S. Myer, *Uprooted Americans: The Japanese Americans and the War Relocation Authority during World War II* (Tucson: University of Arizona Press, 1971), 91–107, xv. For Myer's sincere efforts to be seen as a friend of the internees, see Murray, *Historical Memories*, 56.

13. Murray, *Historical Memories*, 55. Another liberal who wrestled with his sympathy for the internees was the California civil rights lawyer Carey McWilliams. See his memoir, *The Education of Carey McWilliams* (New York: Simon and Schuster, 1978), 101–7. McWilliams refers to Dillon Myer as a "humane and decent man" (104).

14. Leonard, "Years of Hope, Days of Fear," 226.

15. Hayashi, *Democratizing the Enemy*, 22–25, 106. For other analyses of the WRA social scientists, see Orin Starn, "Engineering Internment: Anthropologists and the War Relocation Authority," *American Ethnologist* 13, no. 4 (Nov. 1986): 700–720; as well as the following works already cited: Ichioka, *Views from Within*; Hirabayashi, *Politics of Fieldwork*; and Nishimoto, *Inside a Concentration Camp*. Alice Yang Murray provides a useful overview in *Historical Memories*, 140–84.

16. Drinnon recognizes, though trivializes, the fact that not all the internees experienced confinement as persecution. He says: "The most that can be said is that incarceration had unintended consequences and by-products not all of which were negative." Drinnon, *Keeper of Concentration Camps*, 44.

17. For scholarly accounts of WRA civil rights advocacy, see Leonard, *Battle for Los Angeles*, 255–56; Murray, *Historical Memories*, 84–99; and Kurashige, *Japanese American Celebration and Conflict*, 121–22.

18. Gary Gerstle, *American Crucible: Race and Nation in the Twentieth Century* (Princeton, N.J.: Princeton University Press, 2002), 187–237.

19. Hayashi, *Democratizing the Enemy*, 22–25.

20. See, for example, Drinnon, *Keeper of Concentration Camps*, 50–61. For a discussion of internee critics of Myer's program see, Murray, *Historical Memories*, 102.

21. Hayashi, *Democratizing the Enemy*, 22–25; Eric L. Muller, *American Inquisition: The Hunt for Japanese American Disloyalty in World War II* (Chapel Hill: University of North Carolina Press, 2007), 73–78.

22. On the origins of cultural pluralism, see Philip Gleason, *Speaking Diversity: Language and Ethnicity in Twentieth Century America* (Baltimore: Johns Hopkins University Press, 1992), 51–59; and John Higham, *Send These to Me: Immigrants in Urban America*, rev. ed. (Baltimore: Johns Hopkins University Press, 1984), 198–232.

23. For a discussion of John Collier's ideas within the larger history of cultural pluralism theory, see John Higham, *Hanging Together: Unity and Disunity in American Culture*, edited by Carl J. Guaneri (New Haven, Conn.: Yale University Press, 2001), 117–18.

24. Hayashi, *Democratizing the Enemy*, 22–25.

25. Thomas James, *Exile Within: The Schooling of Japanese Americans, 1942–1945* (Cambridge: Harvard University Press, 1987), 167, 169.

26. Ibid., 164. For a favorable comparison with Canada, where interned Japanese received no public high school education, see ibid., 167.

27. *Boys' Life*, Feb. 2002, 39. Found on Google Books website: http://books.google.com/books?id=1_sDAAAAMBAJ &lpg=PA38&ots=_wK6TBPYC2&dq=norman%20mineta%20 alan%20simpson%20boys'%20life&pg=PA38#v=onepage&q& f=false.

28. By "greatest Nisei generation," I do not mean to mask the continuing racial discrimination or wartime traumas suffered by younger Nisei or the overall ethnic group. For the postwar significance of anti-Japanese racism, see, for example, Kurashige, *Japanese American Celebration and Conflict*, 155–68. For the persistence of wartime traumas, see Donna K. Nagata, *Legacy of Injustice: Exploring the Cross-Generational Impact of the Japanese American Internment* (New York: Plenum Press, 1993).

29. Tom Brokaw coined this phrase in proclaiming that the generation of Americans who lived through the Great Depression and won World War II were the greatest that "any society has ever produced." See Brokaw, *The Greatest Generation* (New York: Random House, 1998).

Contributors

JASMINE ALINDER is associate professor of history at the University of Wisconsin–Milwaukee, where she coordinates the program in public history. In 2009 she published *Moving Images: Photography and the Japanese American Incarceration* (University of Illinois Press). She has also published articles and essays on photography and incarceration, including one on the work of contemporary photographer Patrick Nagatani in the newly released catalog *Desire for Magic: Patrick Nagatani—Works, 1976–2006* (University of New Mexico Art Museum, 2009). She is currently working on a book on photography and the law.

LON KURASHIGE is associate professor of history and American studies and ethnicity at the University of Southern California. His scholarship focuses on racial ideologies, politics of identity, emigration and immigration, historiography, cultural enactments, and social reproduction, particularly as they pertain to Asians in the United States. His exploration of Japanese American assimilation and cultural retention, *Japanese American Celebration and Conflict: A History of Ethnic Identity and Festival, 1934–1990* (University of California Press, 2002), won the History Book Award from the Association for Asian American Studies in 2004. He has published essays and reviews on the incarceration of Japanese Americans and has coedited with Alice Yang Murray an anthology of documents and essays, *Major Problems in Asian American History* (Cengage, 2003).

ERIC L. MULLER is the Dan K. Moore Distinguished Professor at the University of North Carolina School of Law and director of the Center for Faculty Excellence at the University of North Carolina at Chapel Hill. He is the author of many scholarly articles on the incarceration of Japanese Americans in World War II and two books: *American Inquisition: The Hunt for Japanese American Disloyalty in World War II* (University of North Carolina Press, 2007), an account of the bureaucracy that adjudicated the loyalties of Japanese Americans, and *Free to Die for Their Country: The Story of the Japanese American Draft Resisters in World War II* (University of Chicago Press, 2001), which was named one of the *Washington Post*'s top nonfiction

titles in the year of its publication. Since 2003, he has been a member of the board of directors of the Heart Mountain Wyoming Foundation, a nonprofit dedicated to preserving the site and the memory of the Heart Mountain Relocation Center. From 2008 to 2011, as cochair of the foundation's Program Committee, he oversaw the design and creation of the permanent exhibit and introductory film at the Heart Mountain Interpretive Learning Center, which opened in August 2011.

BACON SAKATANI was born to immigrant Japanese parents in El Monte, California, twenty miles east of Los Angeles, in 1929. From the first through the fifth grade, he attended a segregated school for Hispanics and Japanese. Shortly after Pearl Harbor, his family was confined at Pomona Assembly Center and then later transferred to the Heart Mountain Relocation Center in Wyoming. When the war ended in 1945, his family relocated to Idaho and then returned to California. He graduated from Mount San Antonio Community College. Soon after the Korean War began, he served with the U.S. Army Engineers in Korea. He held a variety of jobs but learned computer programming and retired from that career in 1992. He has been active in Heart Mountain camp activities and with the Japanese American Korean War Veterans.

Index

population of, 7; economic activity at, 9; monotony and social control as features of, 9; strike of internees at, 9, 11; leaves and passes for internees, 11, 107; loyalty questionnaires at, 11–12, 109; inmates sent to Tule Lake Segregation Center, 12; draft resistance by Nisei men at, 16, 93, 100 (n. 27); relocating from, 18–19; cameras forbidden at, 21 (n. 16); studies of, 21 (n. 20); children's life at, 23–34; barracks at, 25; transport from California to, 25; dining facilities at, 27; guard towers at, 27, 33, 97, 106–7; schools at, 27–28, 113; activities for youth at, 27–31; recreation buildings at, 28; Yellowstone National Park trips from, 31, 107; latrines at, 32; wine-making at, 32; first reunion of internees at, 33; as "American-style" concentration camp, 34; camera club at, 85; professional photojournalists take photographs of, 85–87; dancing at, 87, 91, 111; fence as charged symbol at, 97, 106–7; demand for professional portrait photography at, 101 (n. 31); interpretive center established at, 103; Simpson visits, 103

Heart Mountain Sentinel (newspaper), 85, 87, 97, 107

Hirabayashi, Lane, 106

Hirahara, George, 100 (n. 10)

Hiroshima Kenjinkai, 23

Holland, Patricia, 83

Hosokawa, Bill, 87

Ice skating, 23, 27, 33, 94

Ichioka, Yuji, 105

Inouye, Daniel, 104

Internment: evacuation from exclusion zones, 5–6; War Relocation Authority's attempts to relocate internees, 11, 14, 109, 110; activities for youth during, 23, 25, 27–31, 113; education during, 27–28, 113; Nazi concentration camps compared with, 104; politics of redress polarizes debate about, 104–5; wider outlook on, 105, 106; utilitarian view of scholarship on, 105, 107, 114; diversity view of, 105–6. *See also* Assembly centers; Relocation centers

Iriye, Akira, 105

Irons, Peter, 104, 115 (n. 4)

Issei, 2; land ownership denied to, 2, 20 (n. 4); arrests in 1942, 4, 24; at Santa Anita Assembly Center, 6; loyalty questionnaire questions for, 11, 21 (n. 23); opportunities at camps for, 33; cameras remain contraband for, 85, 100 (n. 9); Americanization of, 110, 113

Itaya, Eunice: as Nisei, 3; birth of, 4; leaves Los Angeles, 5; arrives at Heart Mountain Relocation Center, 7; leaves Heart Mountain, 19

Itaya, Junzo, 2; rhubarb farm of, 2, 5–6, 19; children of, 4; arrest and detention of, 4, 83; arrives at Heart Mountain Relocation Center, 7; job at Heart Mountain, 9; financial situation deteriorates, 18; attempts to leave Heart Mountain, 18–19; moves in with Bill and Mary Manbo, 19; evades restrictions on land ownership, 20 (n. 4); on Application for Leave Clearance, 21 (n. 24)

Itaya, Mary. *See* Manbo, Mary

Itaya, Riyo, 2; children of, 4; arrives at Heart Mountain Relocation Center, 7; job at Heart Mountain, 9; financial situation deteriorates, 18; nervous breakdown of, 18; moves in with Bill and Mary Manbo, 19

Itaya, Sammy: as Nisei, 3; birth of, 4; leaves Los Angeles, 5; and family rhubarb farm, 6, 20 (n. 4); arrives at Heart Mountain Relocation Center, 7; works at Cheyenne bowling alley, 11; does farm work in Illinois, 16, 18; service in U.S. military, 16, 21 (n. 25)

Itaya family, 2; rhubarb farm of, 2, 5–6, 19; leave Los Angeles, 5; at Santa Anita Assembly Center, 6; arrive at Heart Mountain Relocation Center, 7; relocate from Heart Mountain, 18–19

Iwasaki, Hikaru Carl, 87, 88, 100 (n. 13)

James, Thomas, 113

Japanese Americans: three generations of, 2; truck farming by, 2, 23; Pearl Harbor attack's effect on, 4, 24, 83; calls for mass reprisals against, 4–5; exclusion zones for, 5; West Coast reopened to, 18; effects of Manbo's photographs on, 20; disloyalty associated with, 20, 91, 107, 109; cameras forbidden to, 21 (n. 16), 84–85, 99; "No Japs" signs in towns, 28; redress legislation for, 33, 103, 104–5; opportunities at camps for, 33–34; photography as representational battleground for, 83; War Relocation Authority's photographs of, 83–84; two-thirds as American citizens, 84; tensions in cultural acts of, 91; gap in family albums of, 94; War Relocation Authority's sympathetic attitude toward, 107, 109; War Relocation Authority acts as civil rights agent for, 109; postwar repeal of discriminatory legislation against, 110. *See also* Issei; Japanese culture; Nisei

Japanese culture: Bon Odori celebration, 7, 15, 23, 83, 88, 93;